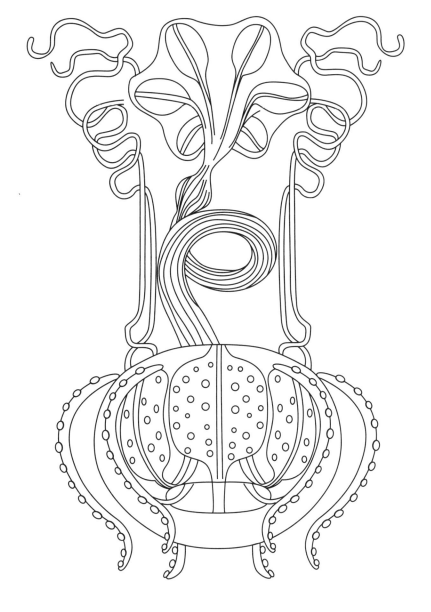

ART
FORMS IN
NATURE

Copyright © 2016 Prestel Verlag,
Munich · London · New York,
a member of Verlagsgruppe Random House GmbH
Neumarkter Straße 28 · 81673 München

Prestel Publishing Ltd.
14-17 Wells Street
London W1T 3PD

Prestel Publishing
900 Broadway, Suite 603
New York, NY 10003

Prestel books are available worldwide. Please contact your nearest
bookseller or one of the above addresses for information concerning
your local distributor.

Illustrations: Barbara Dziadosz

Editorial direction: Doris Kutschbach
Coverdesign: SOFAROBOTNIK, Augsburg
Design: Meike Sellier
Production: Astrid Wedemeyer
Printing and Binding: DZS Grafik, d.o.o., Ljubljana
Paper: Tauro

Verlagsgruppe Random House FSC® N001967

Printed in Slovenia

ISBN 978-3-7913-7259-4
www.prestel.com

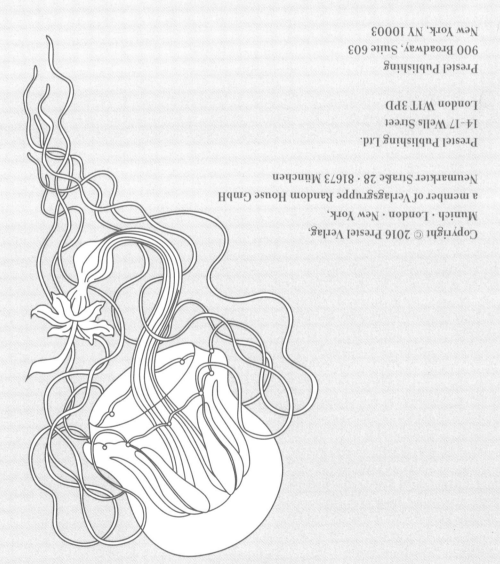

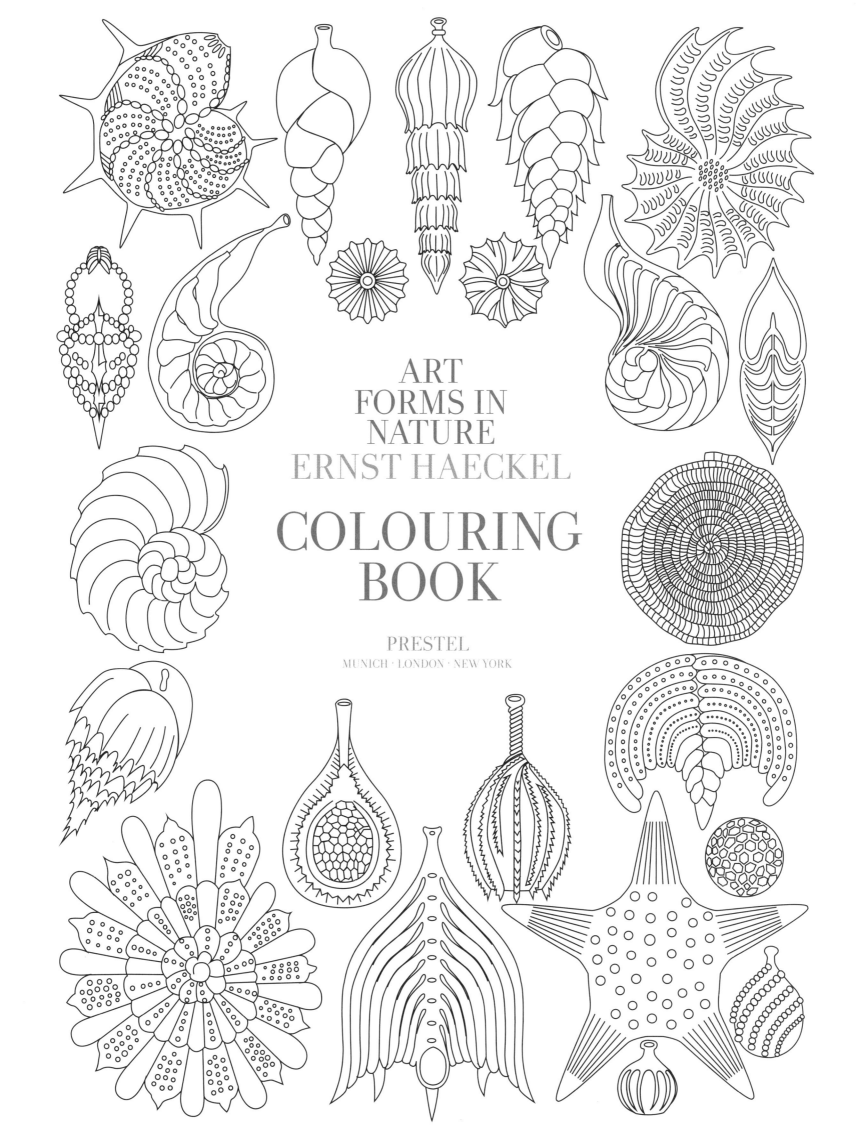

ART
FORMS IN
NATURE
ERNST HAECKEL

COLOURING
BOOK

PRESTEL
MUNICH · LONDON · NEW YORK

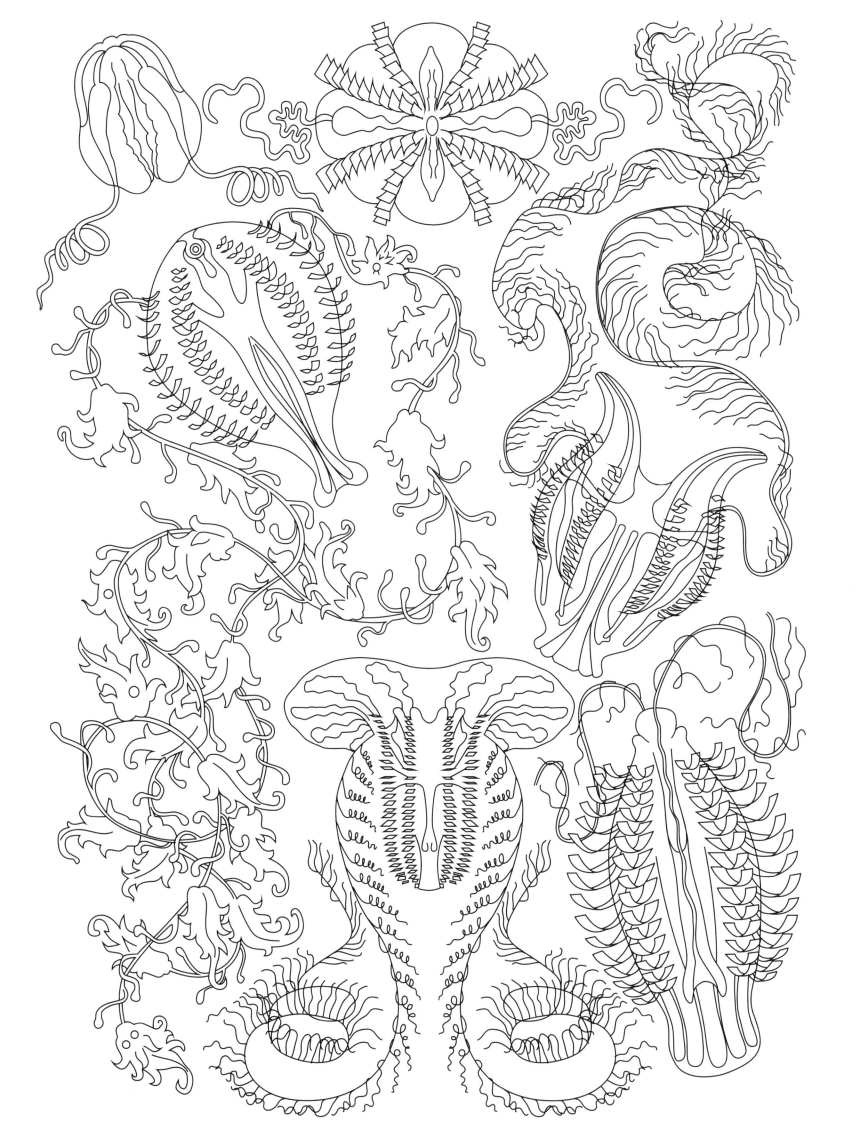

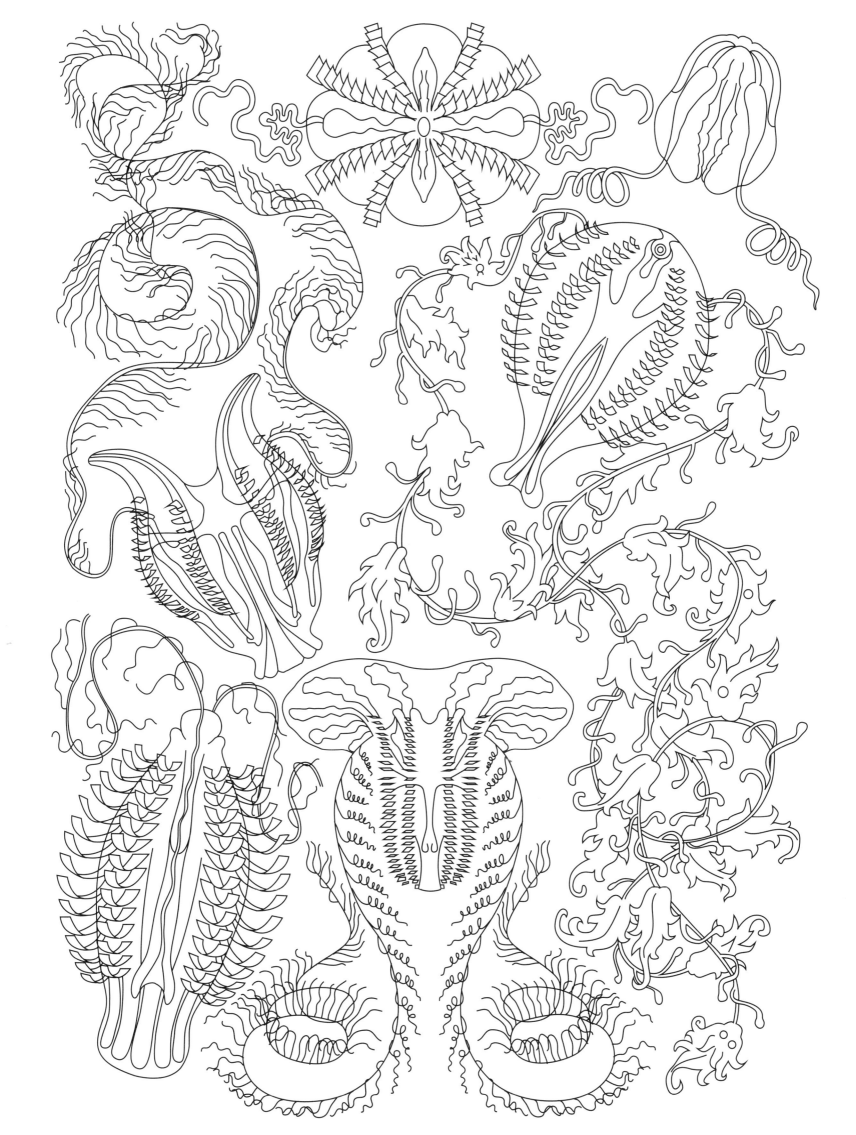

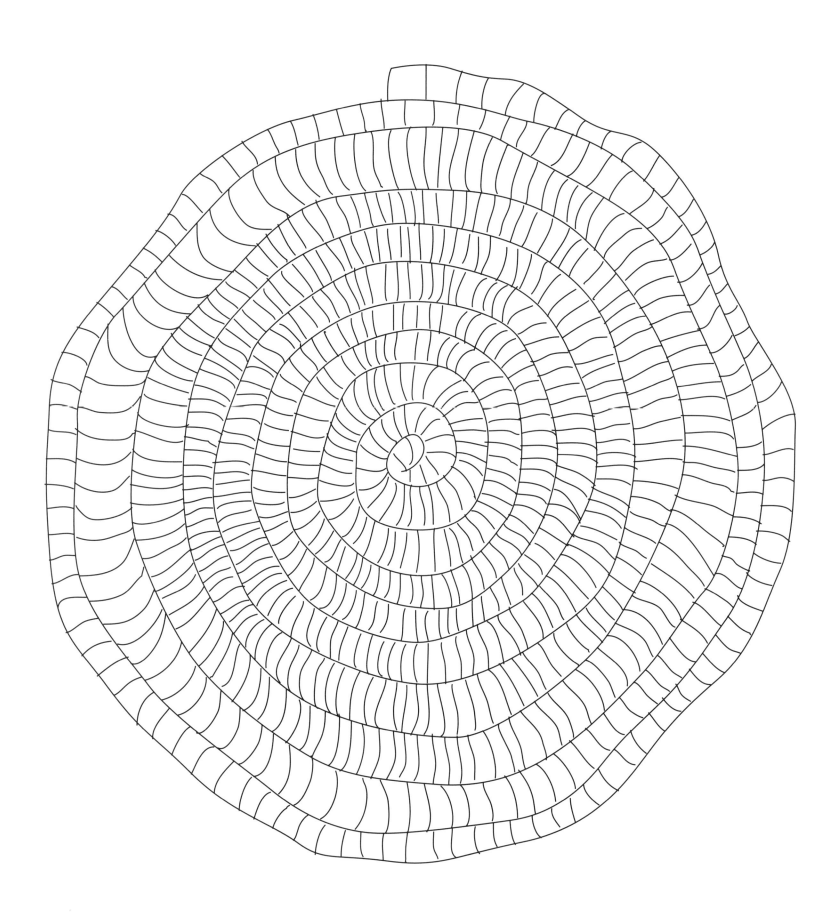

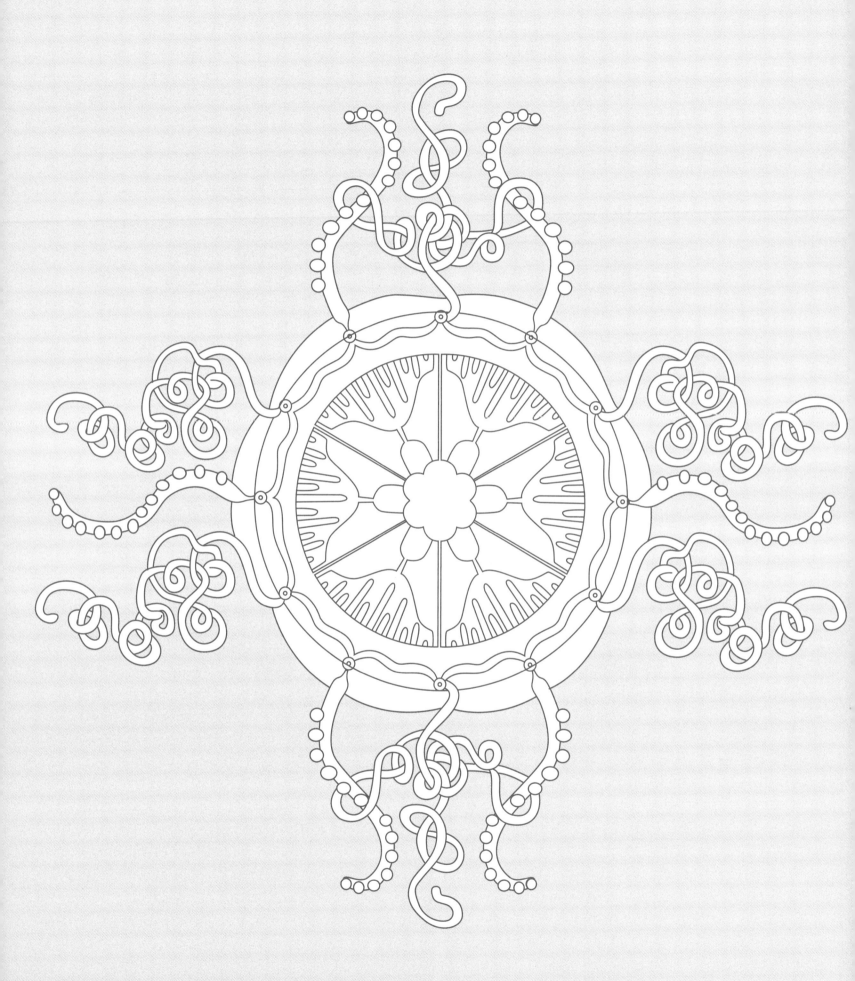

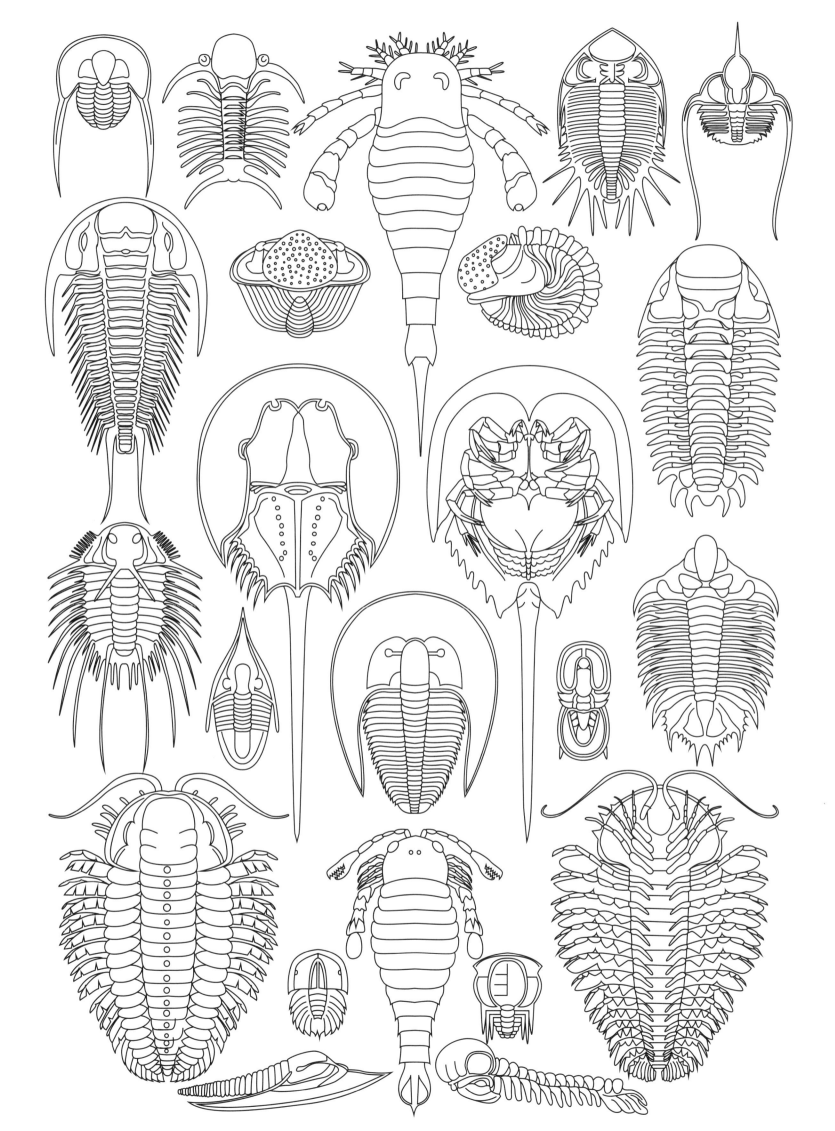

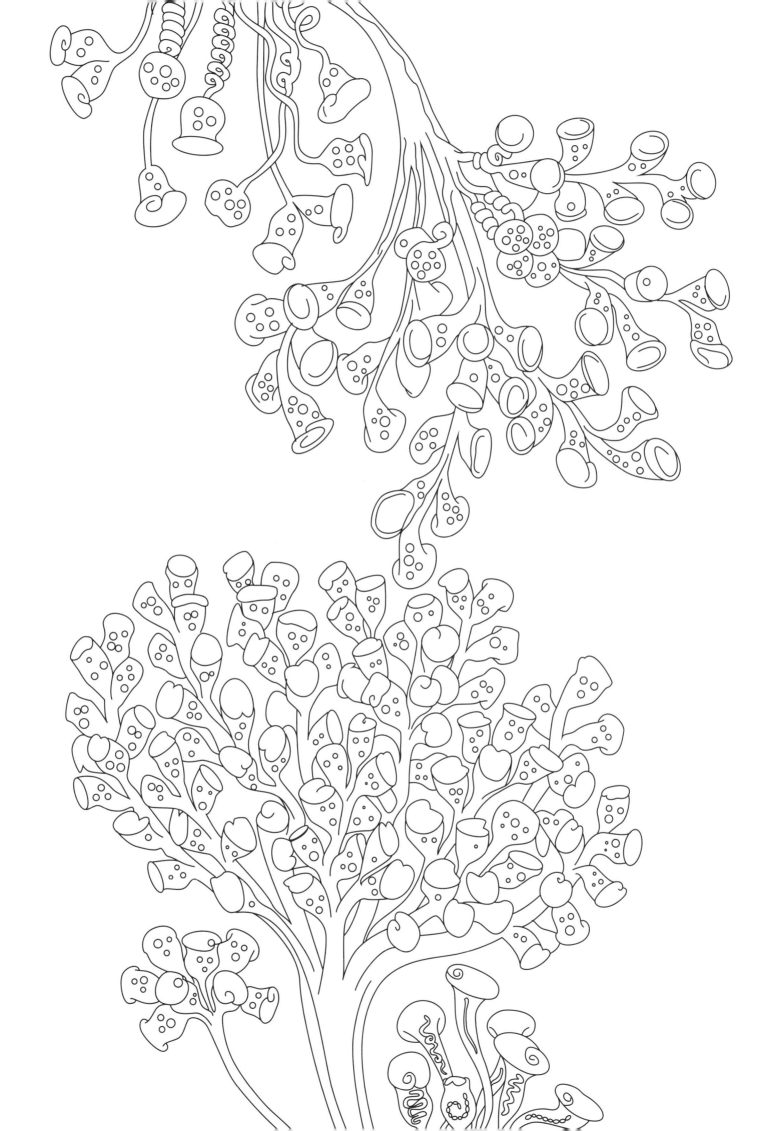

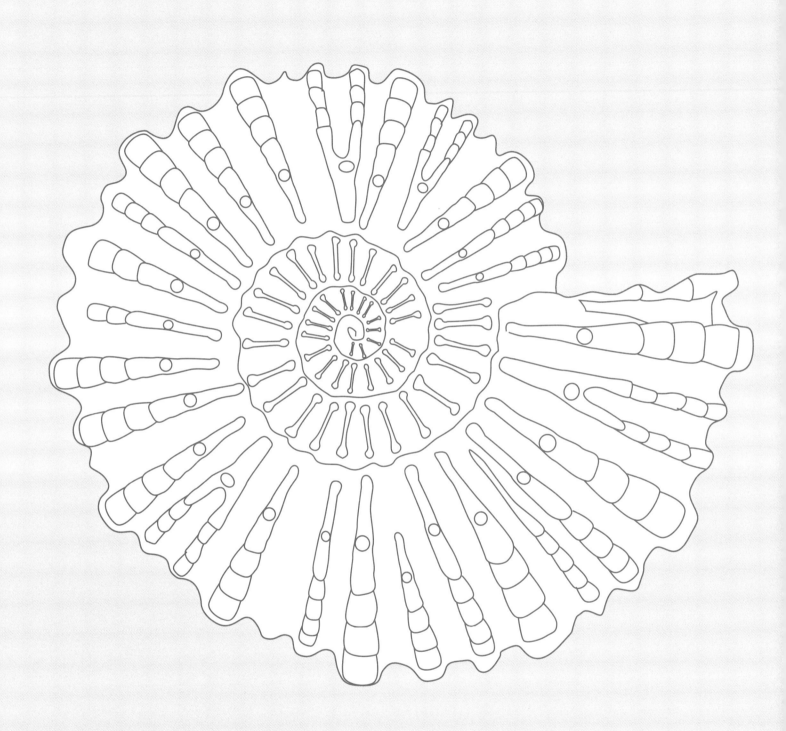

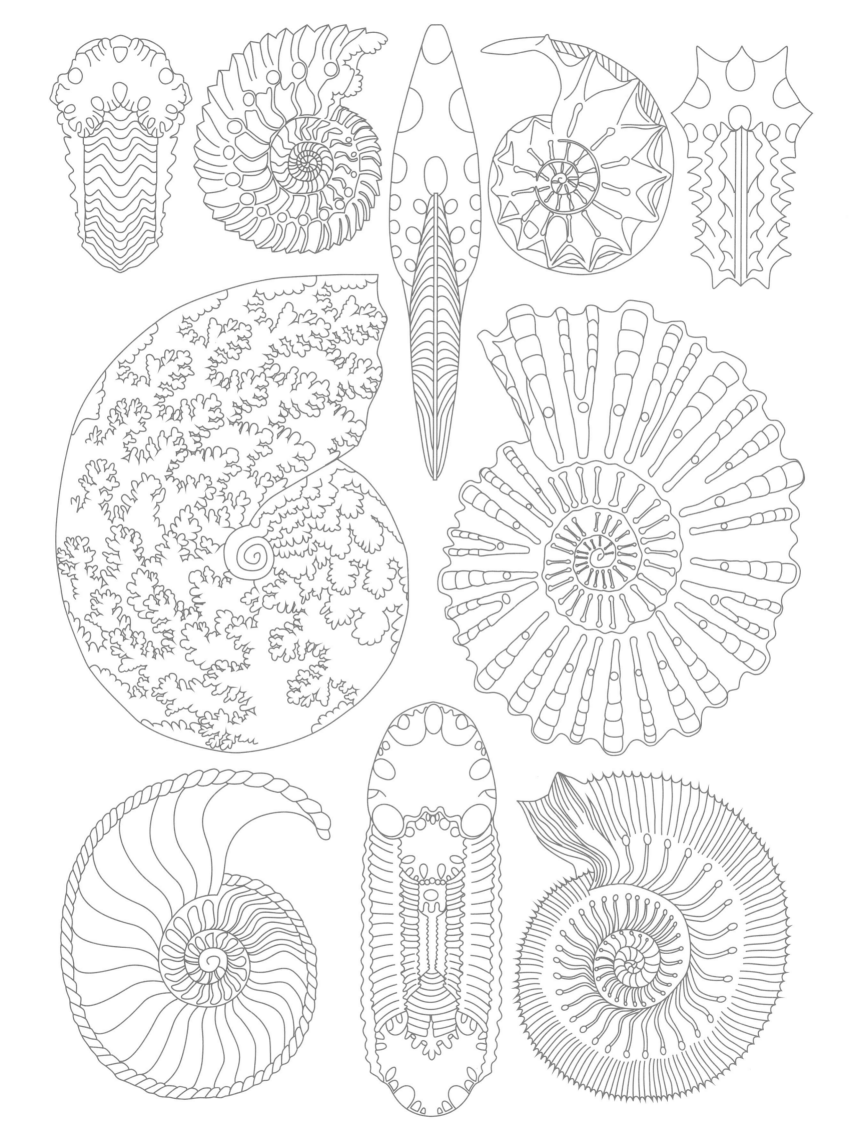

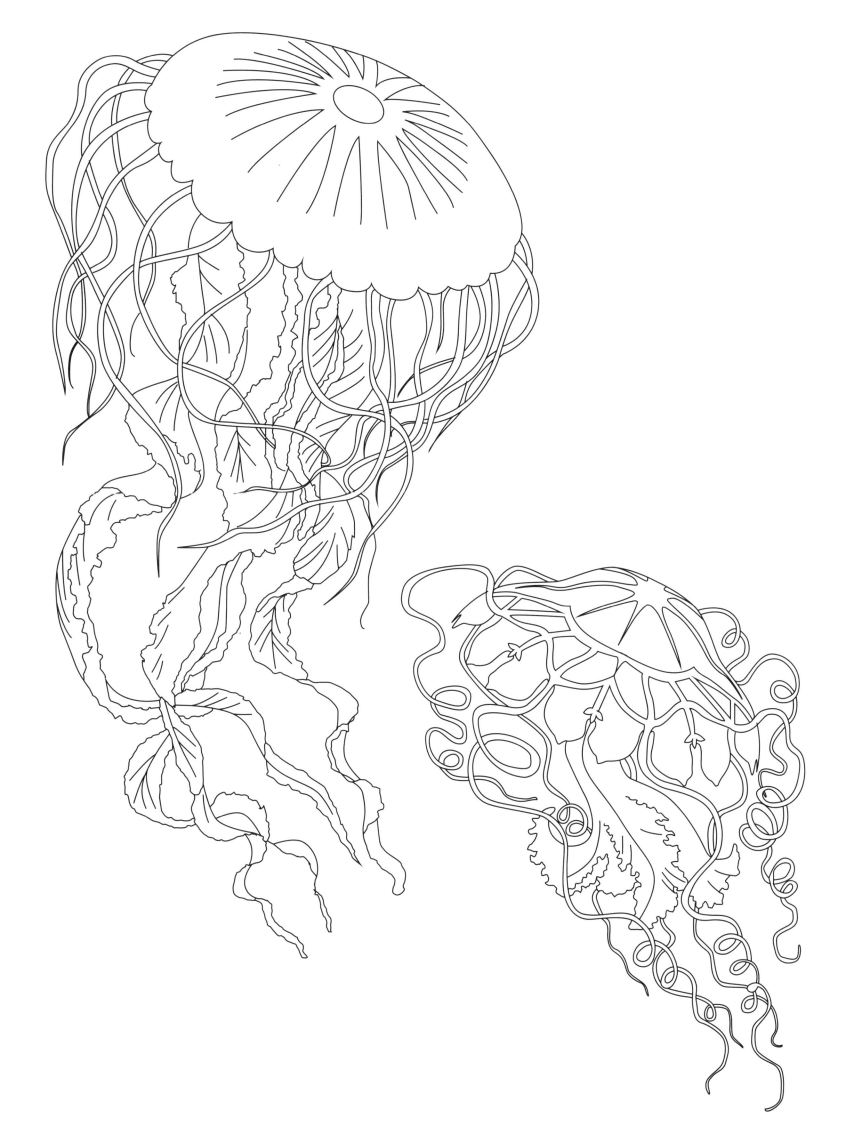

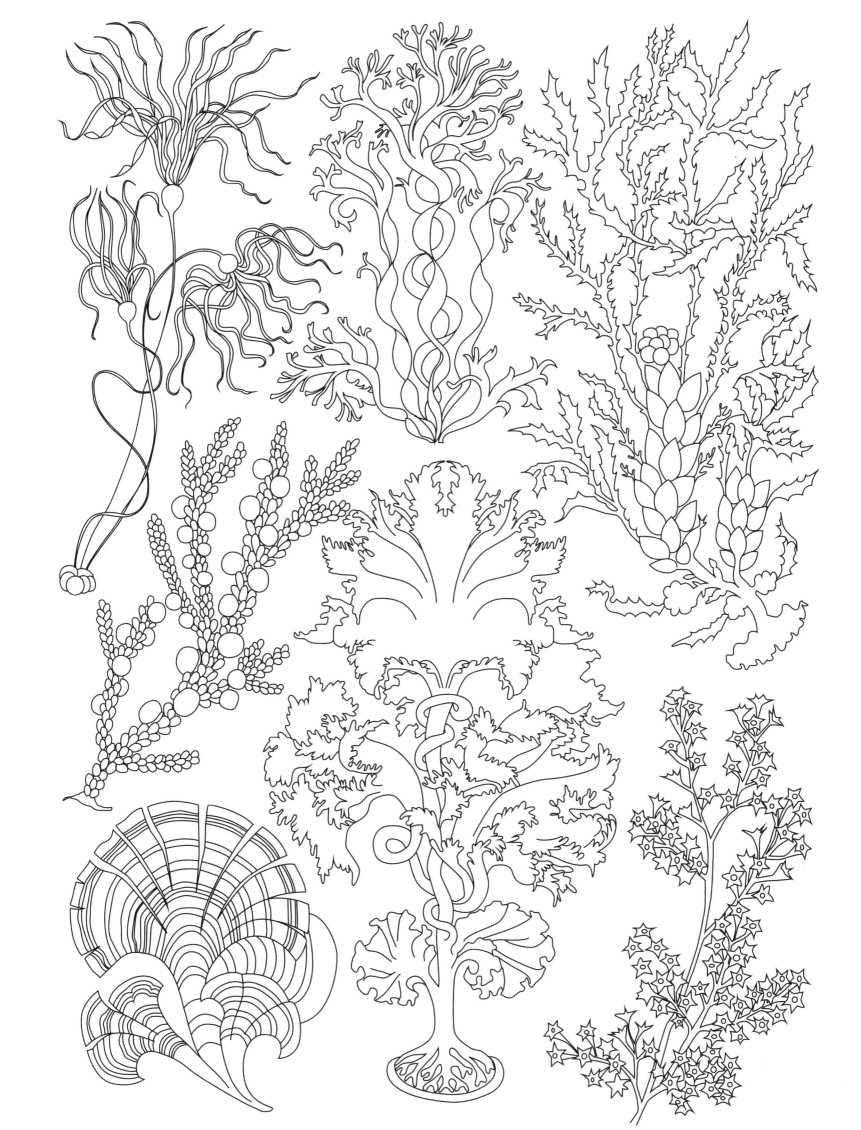

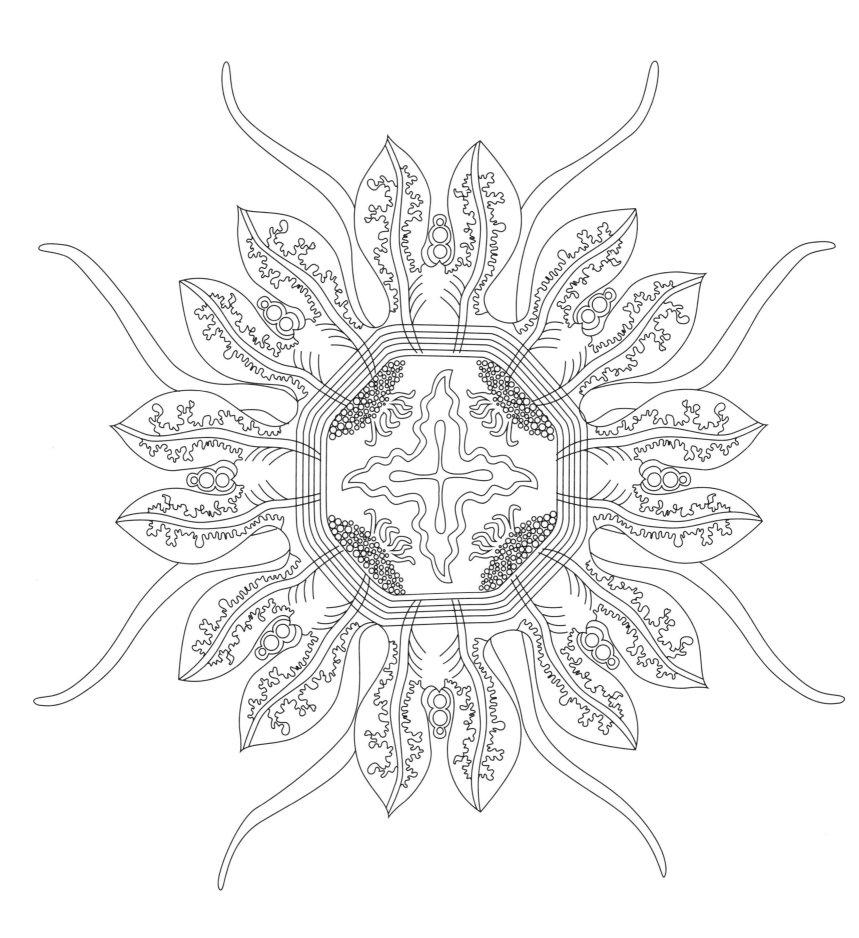

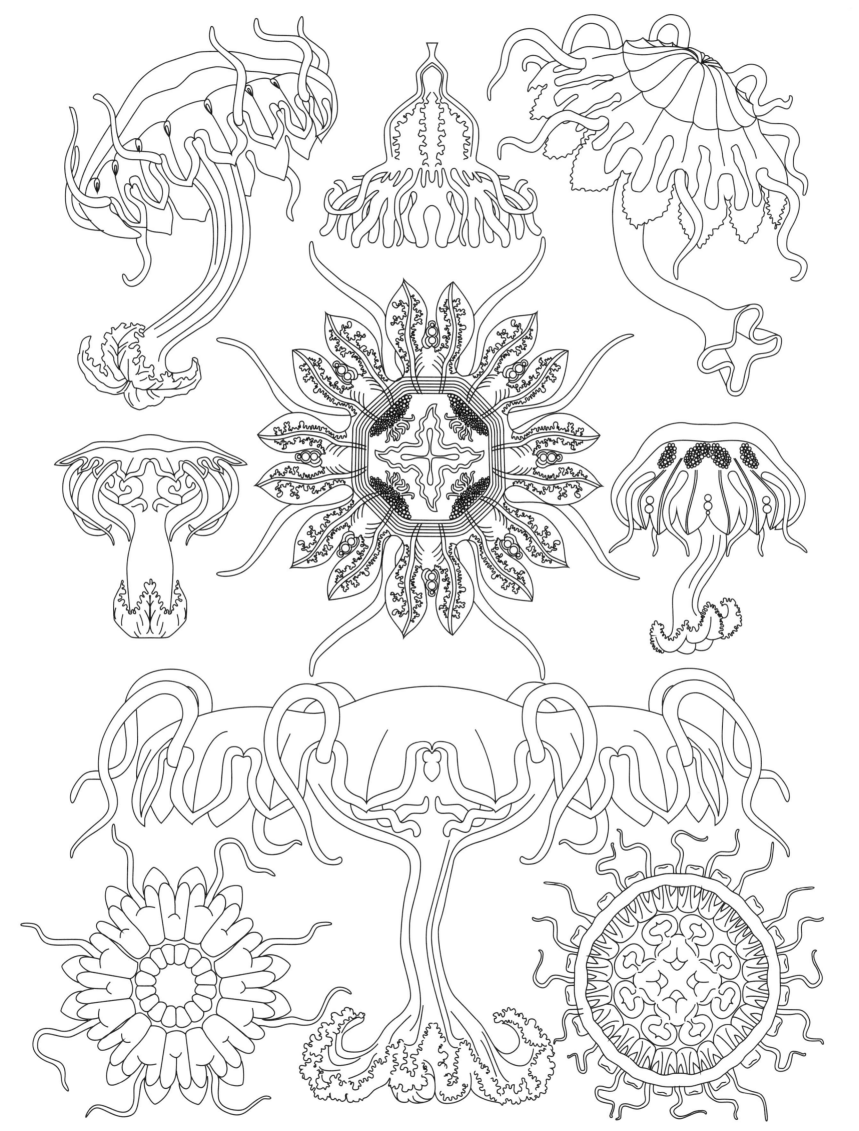

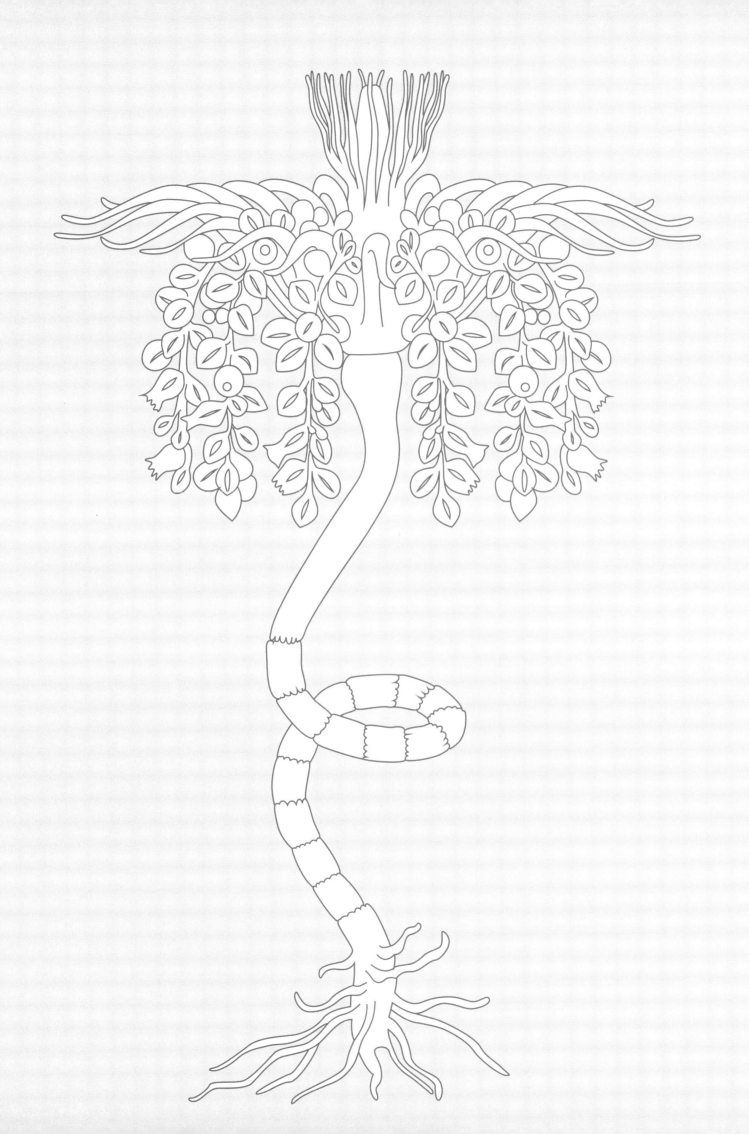

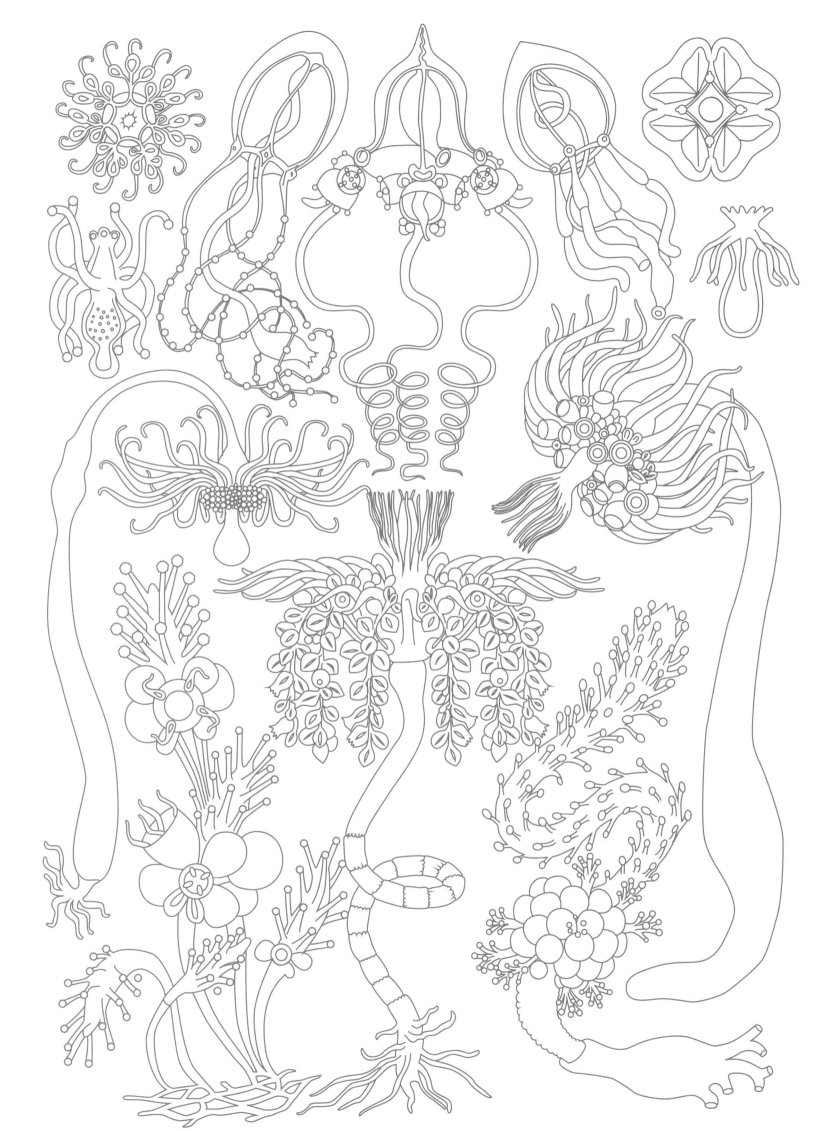

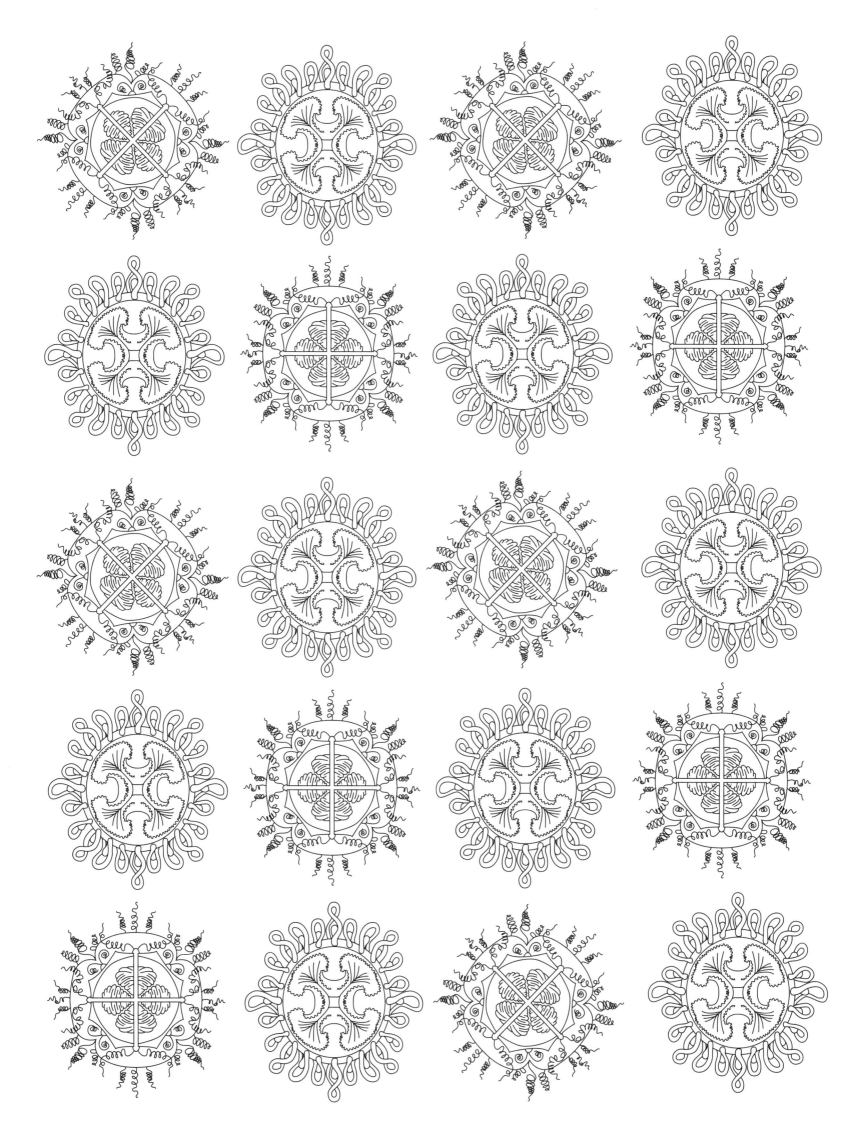

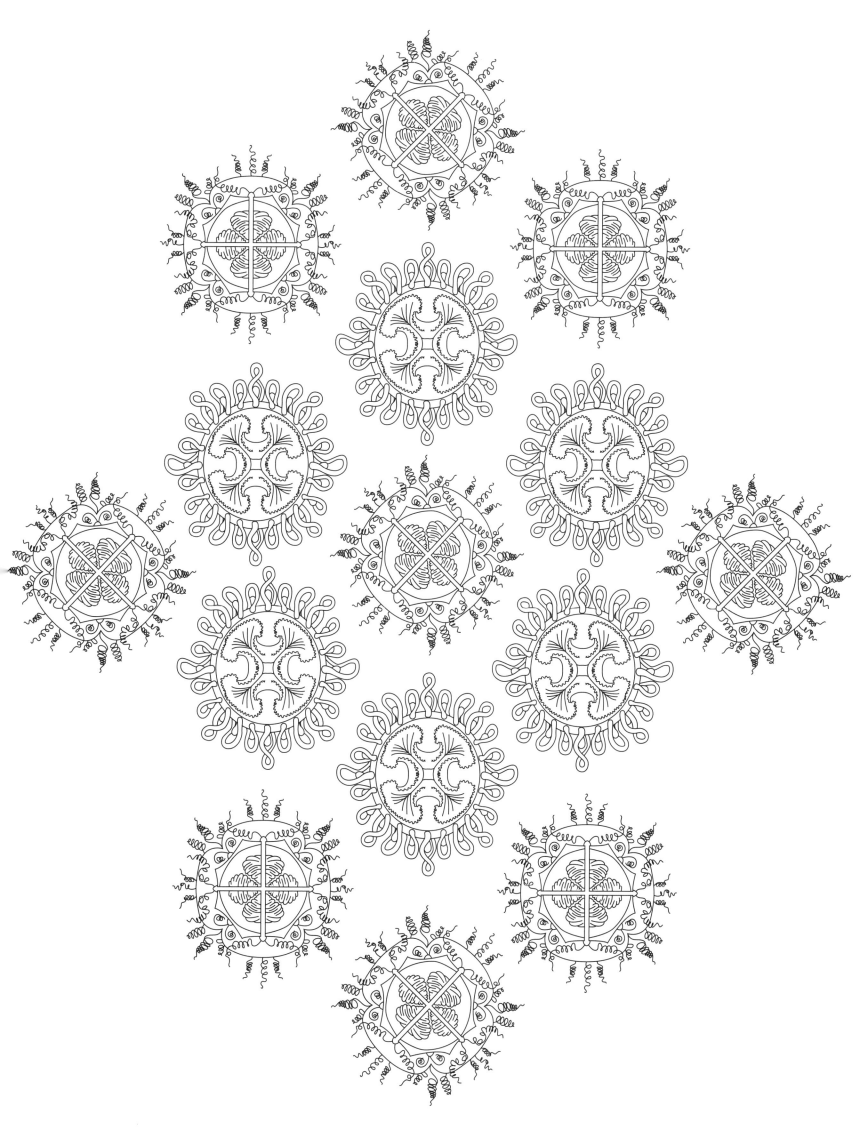

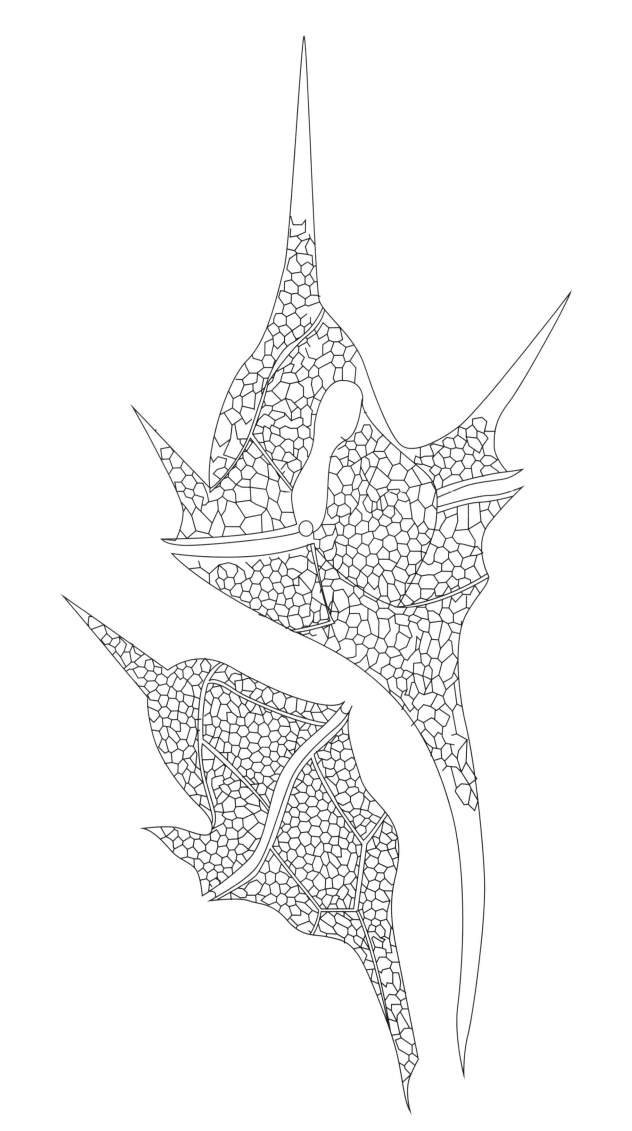

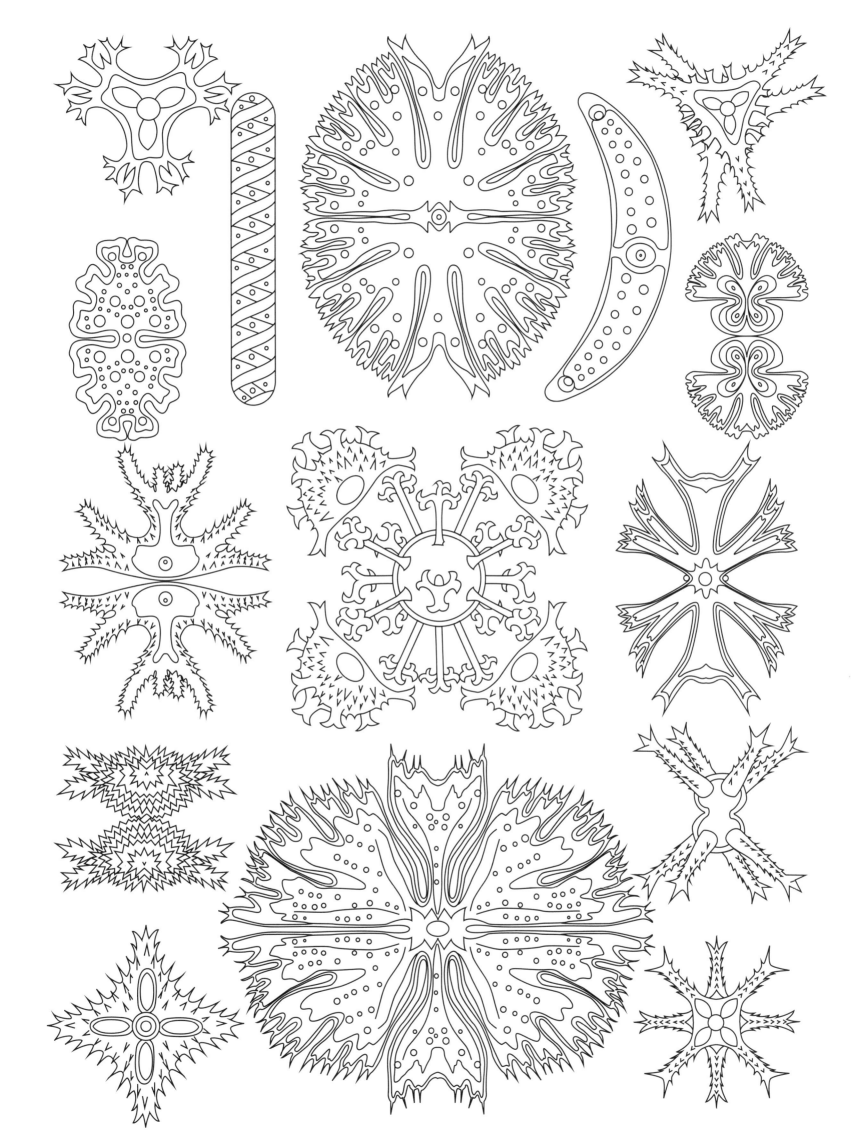

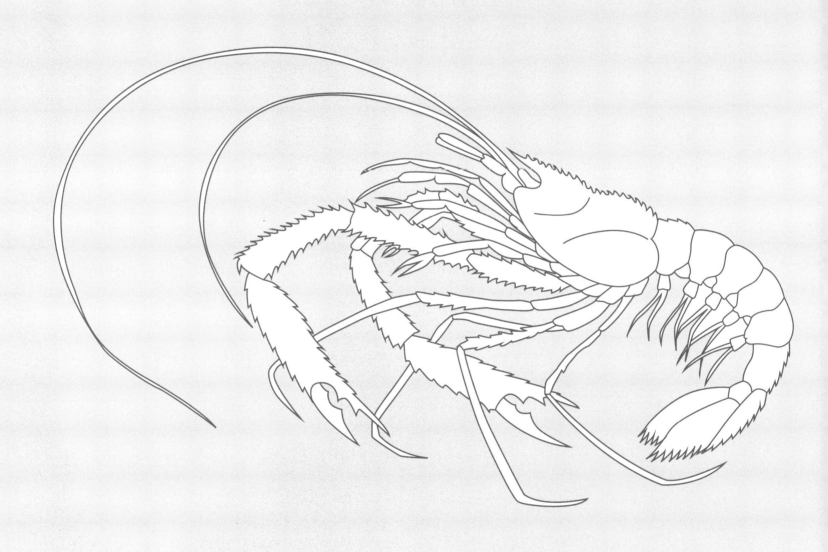

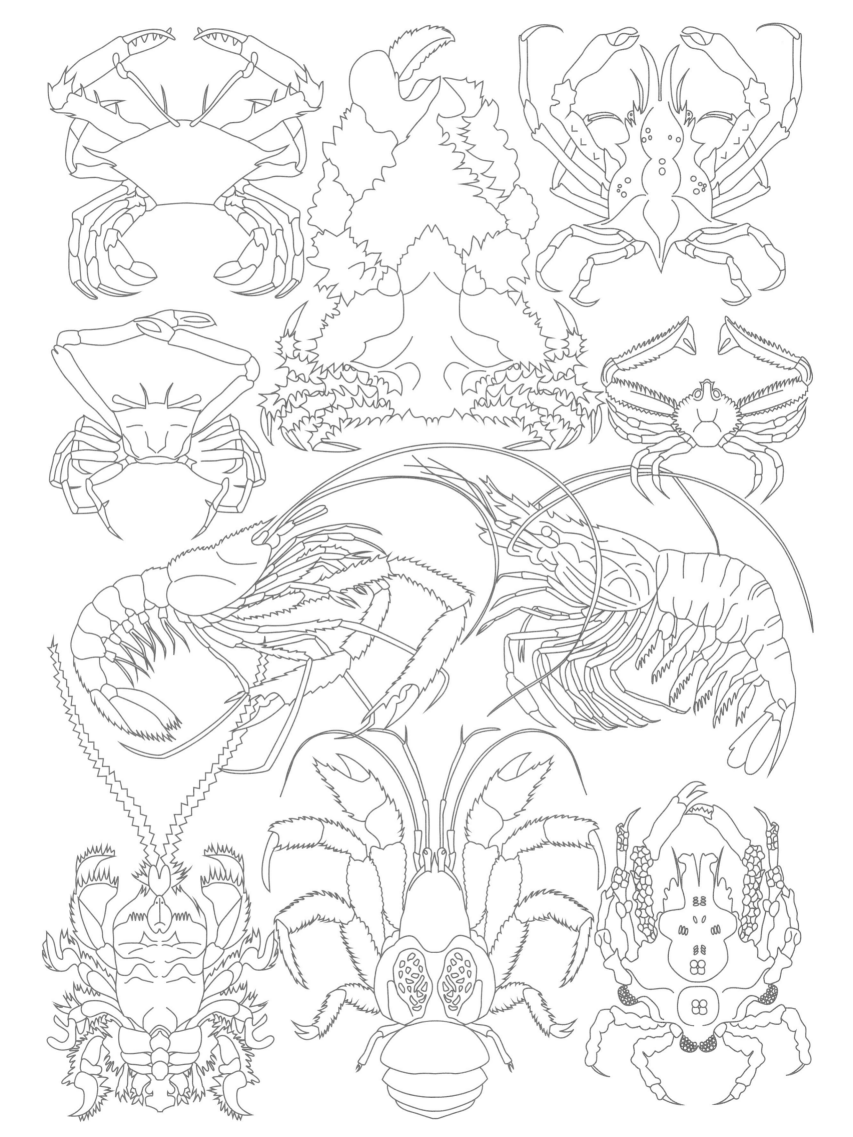

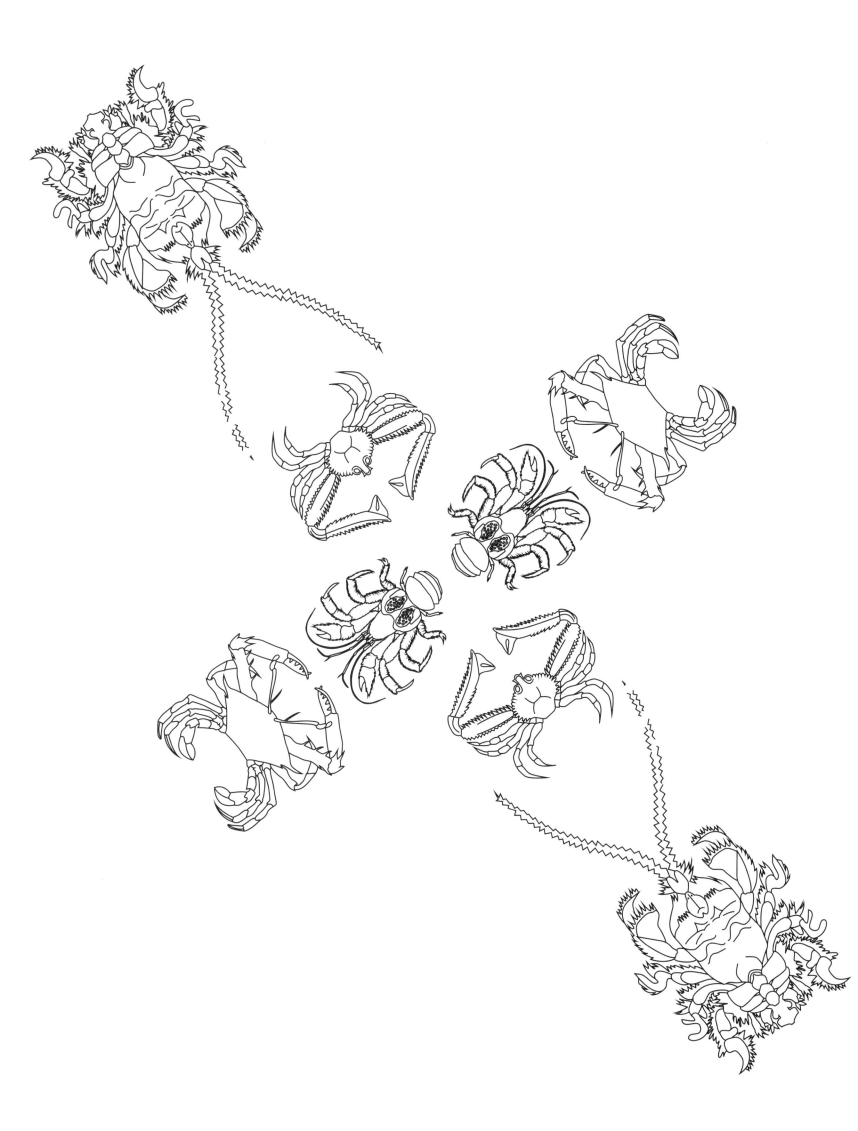

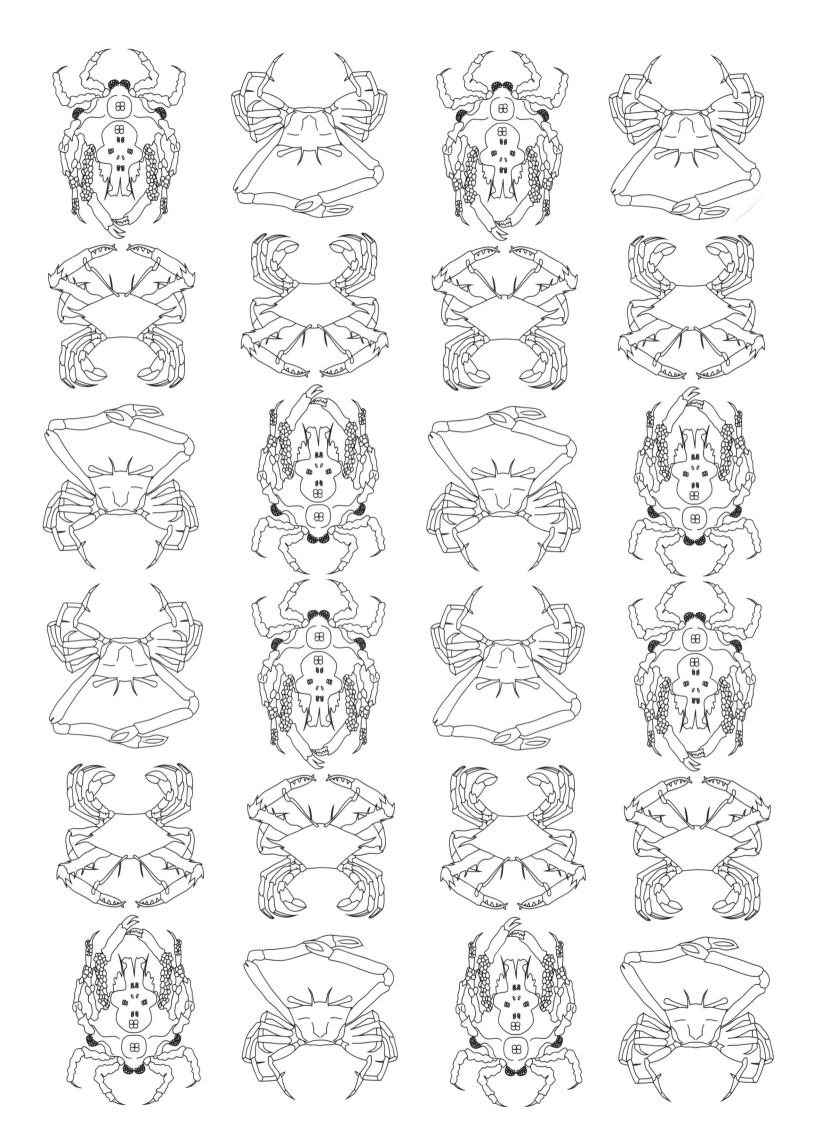

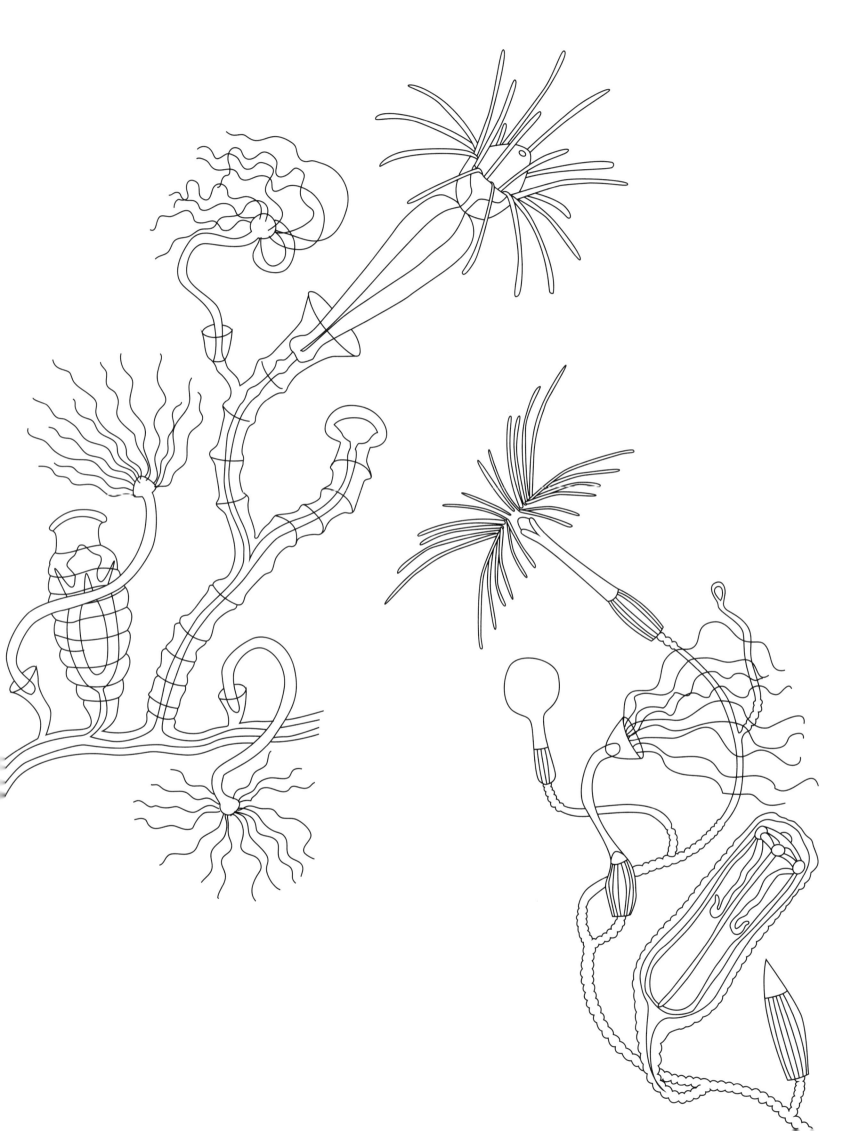

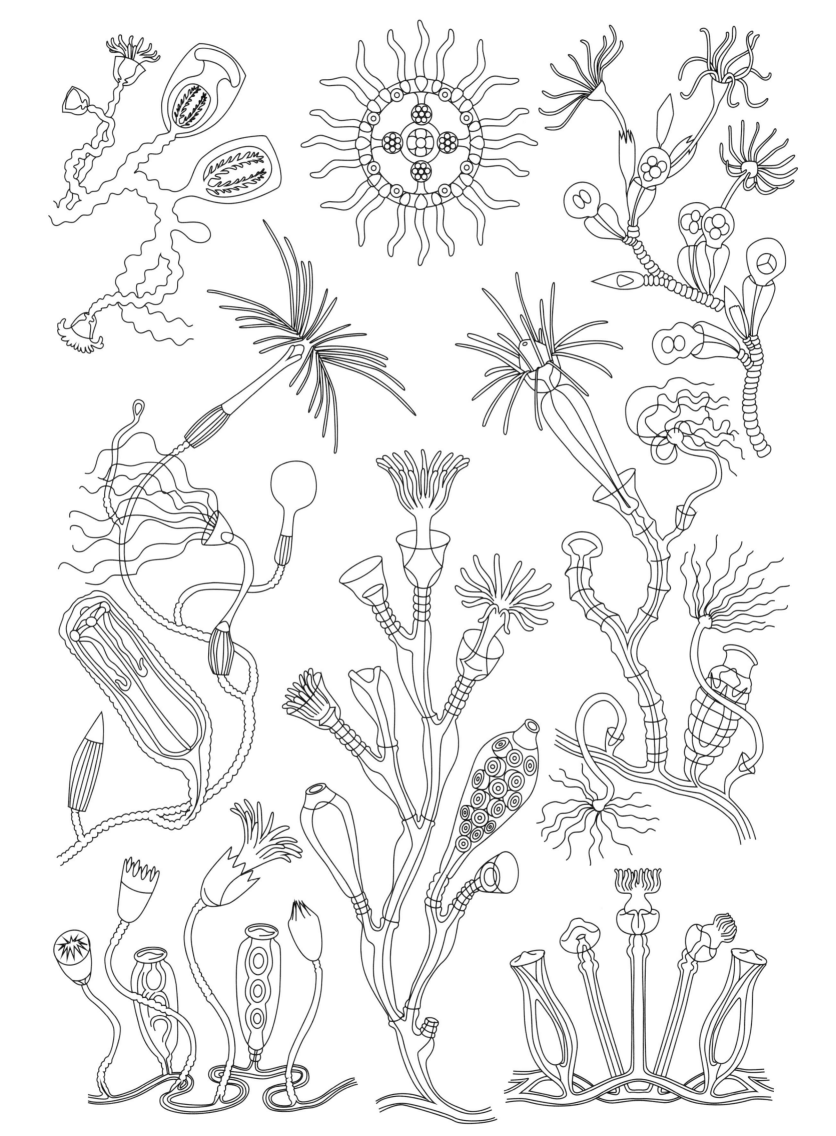

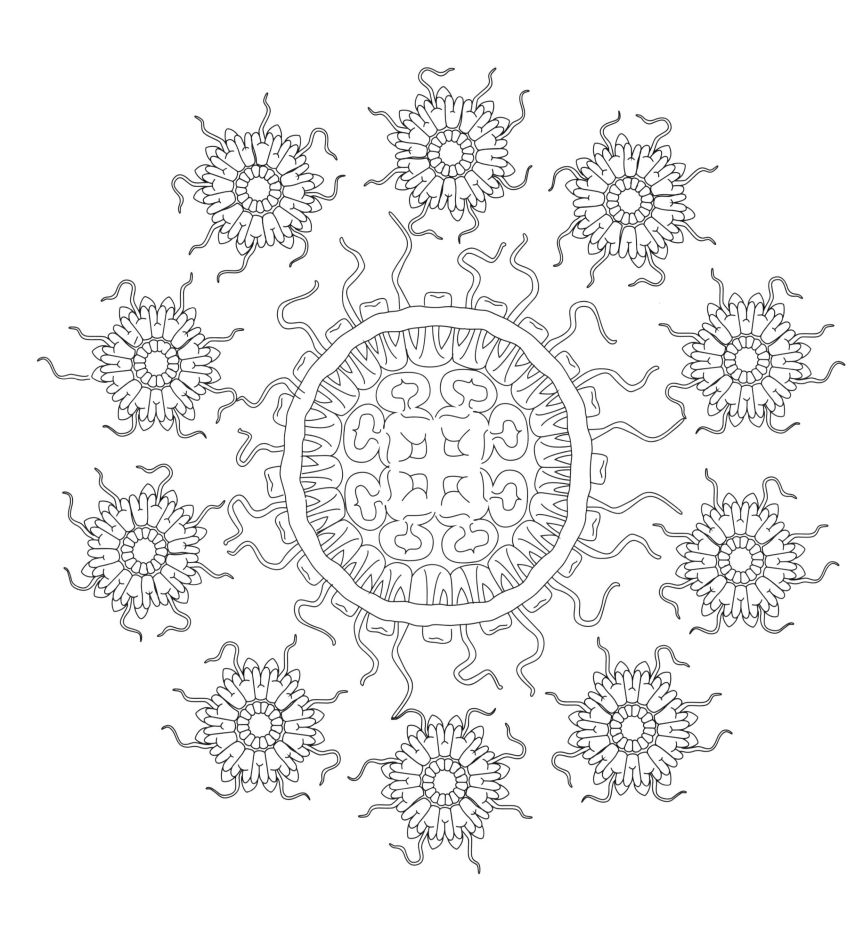

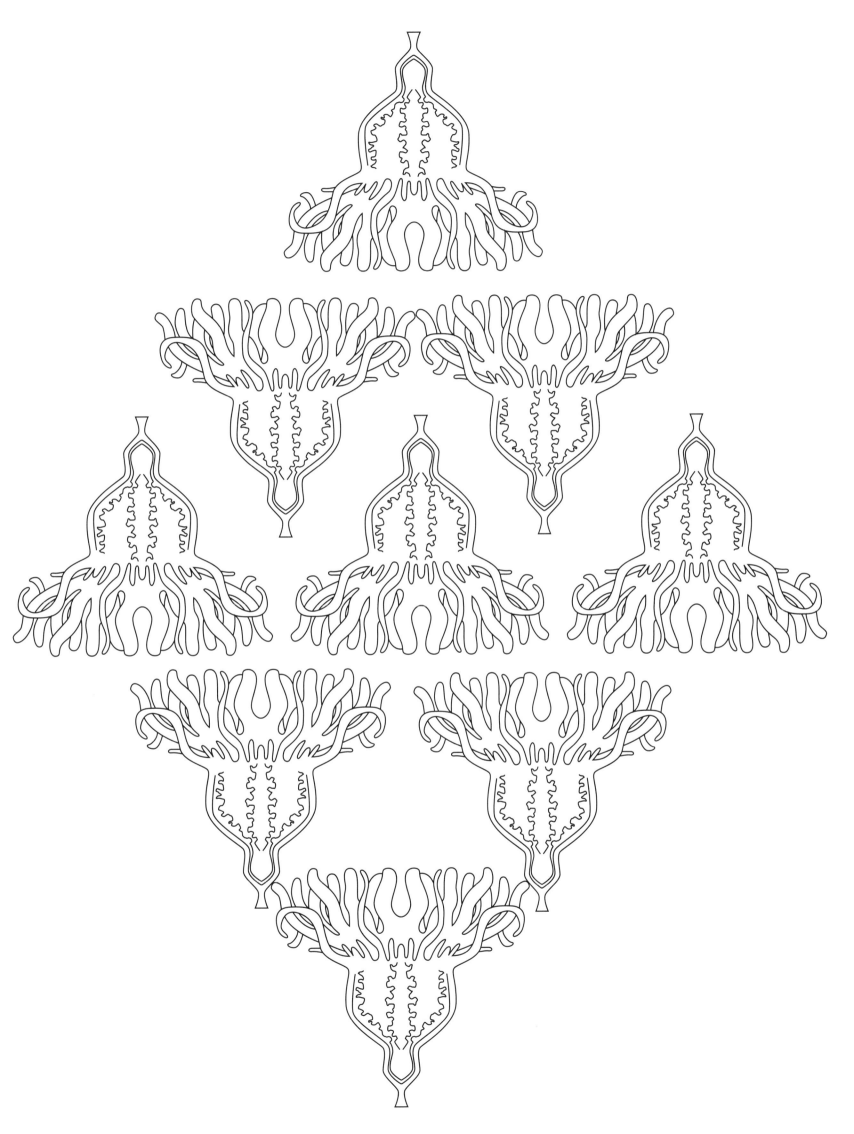

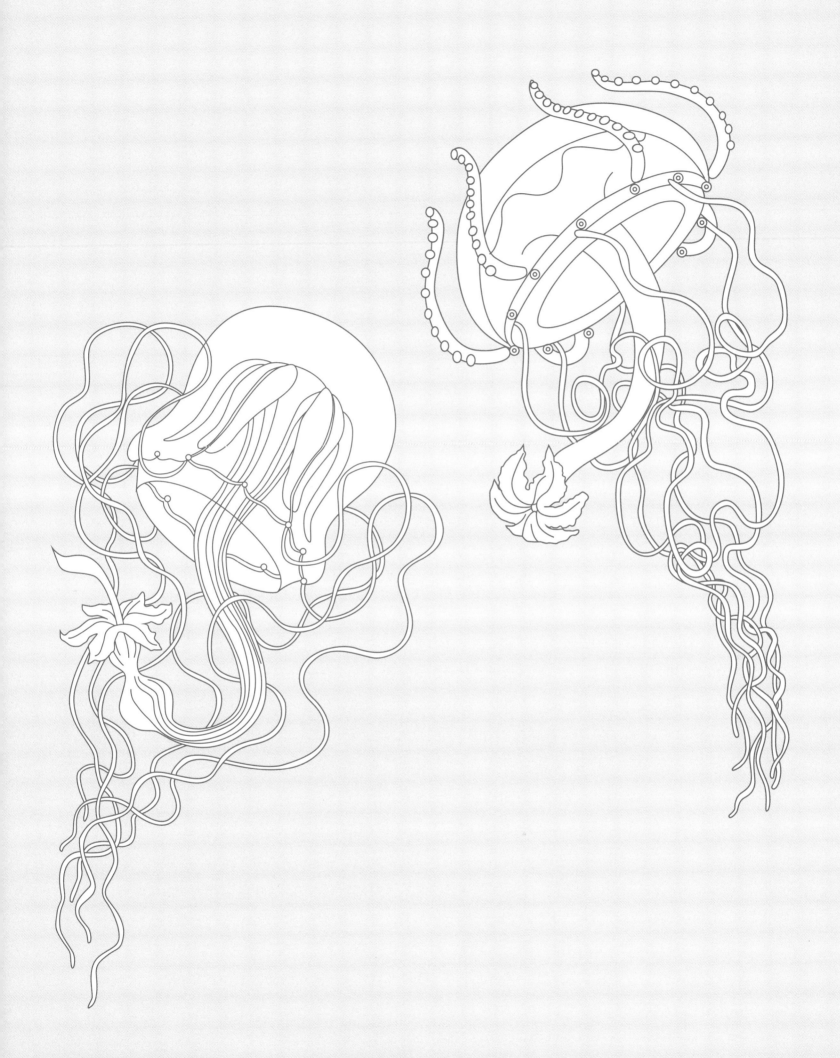

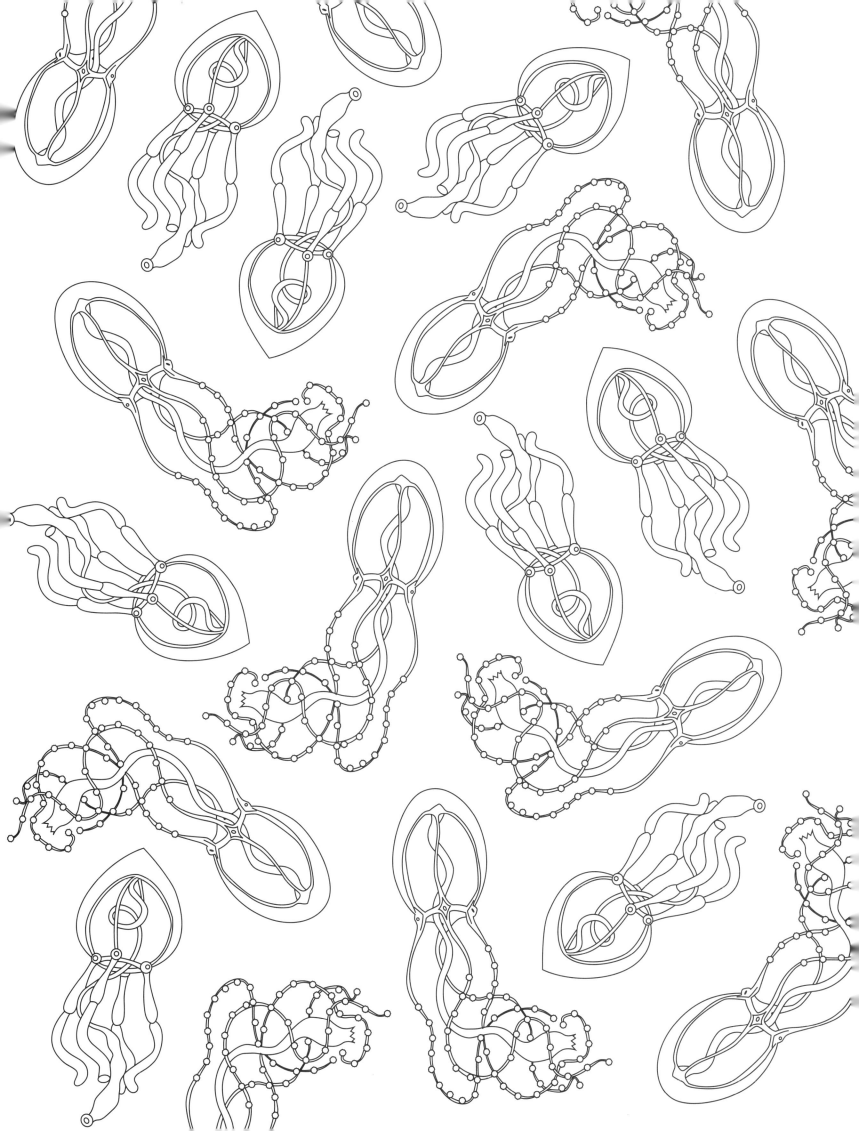

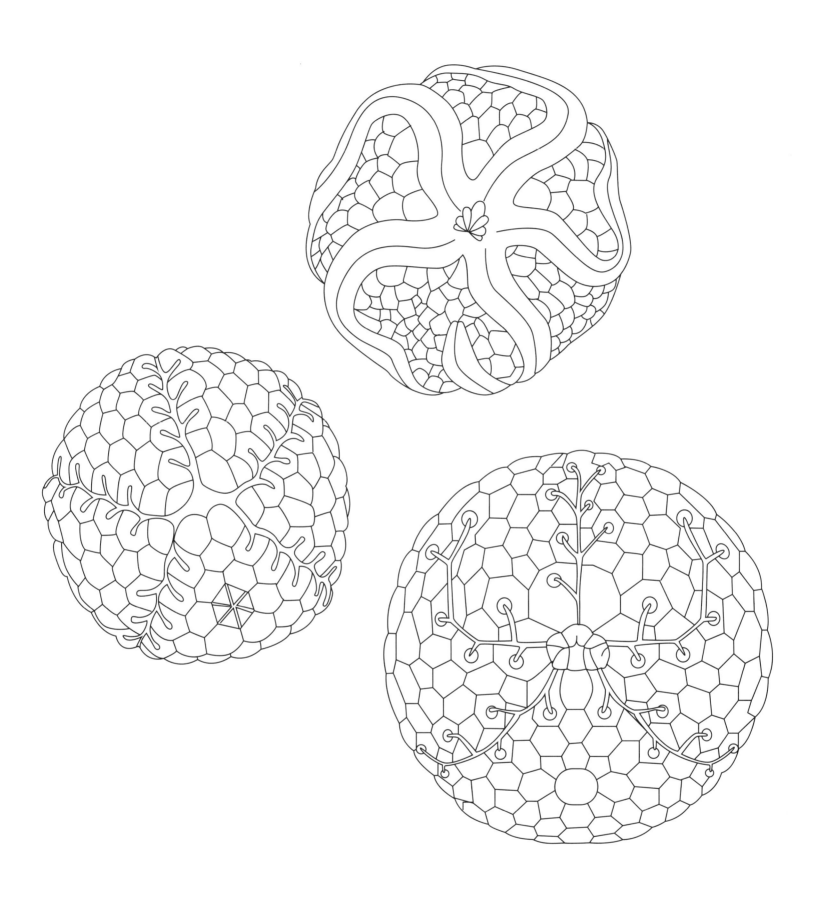

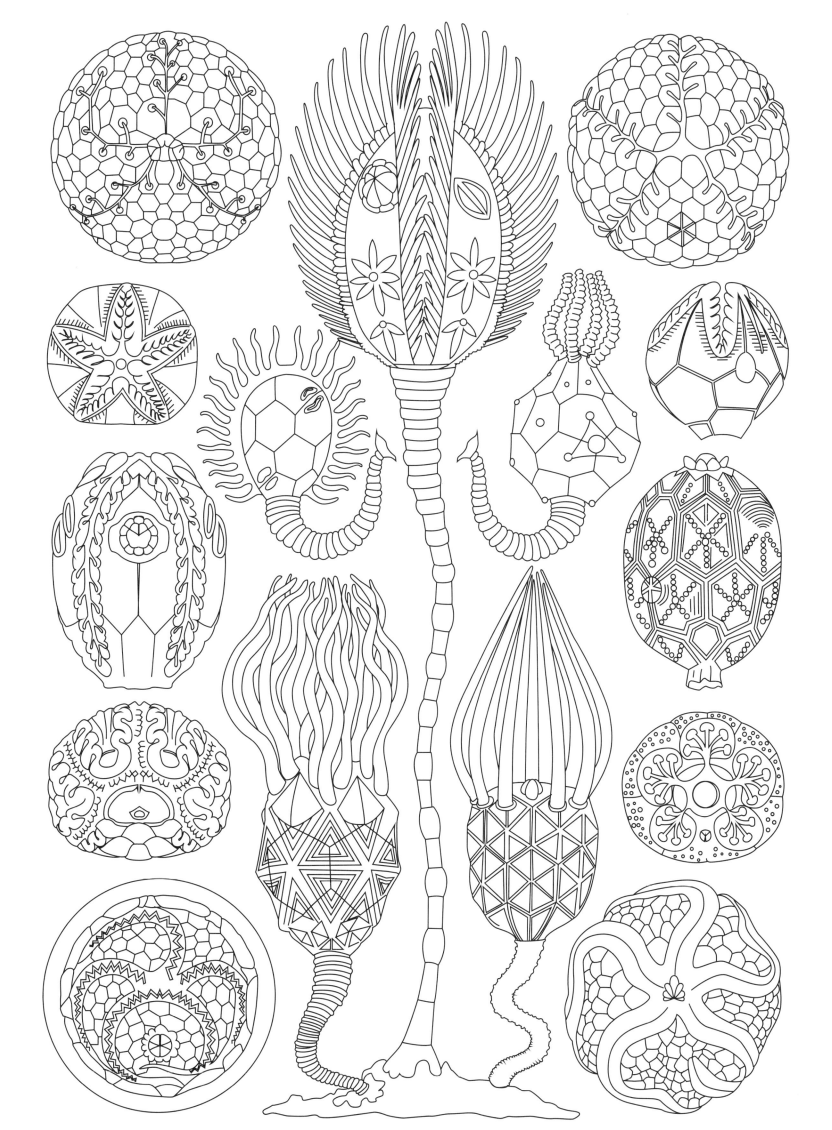

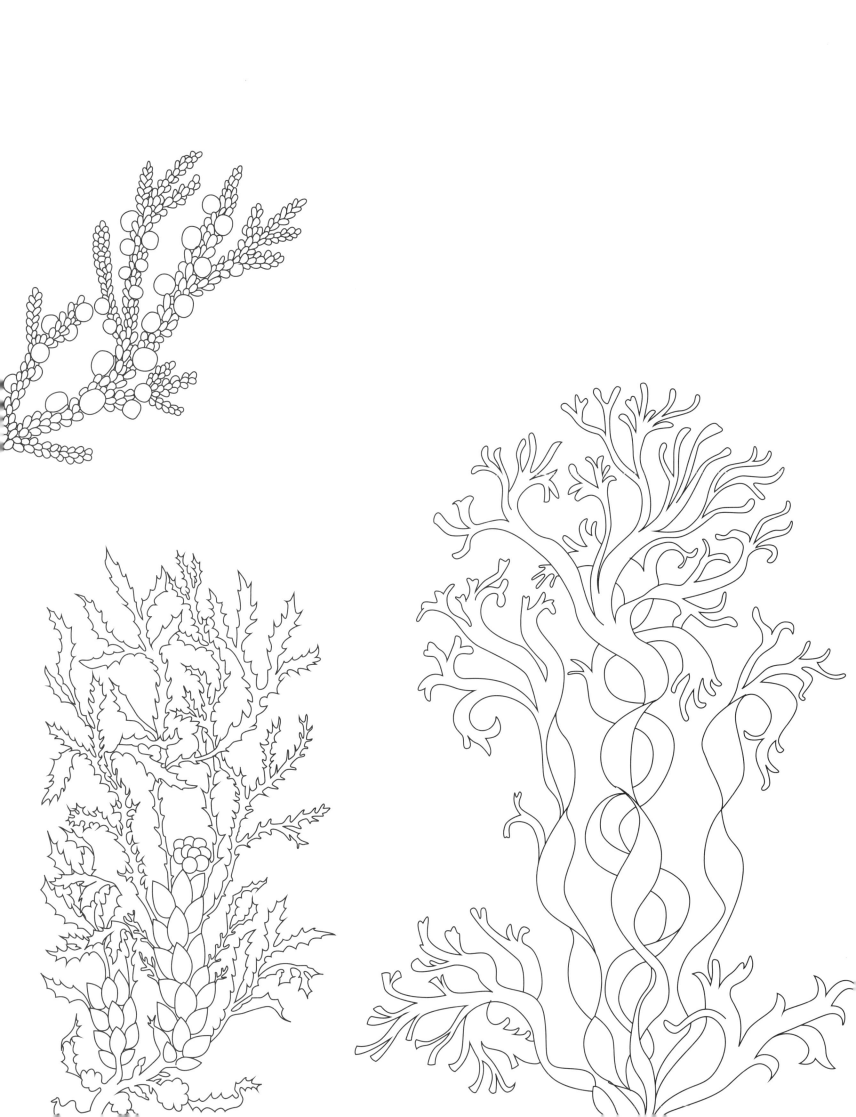

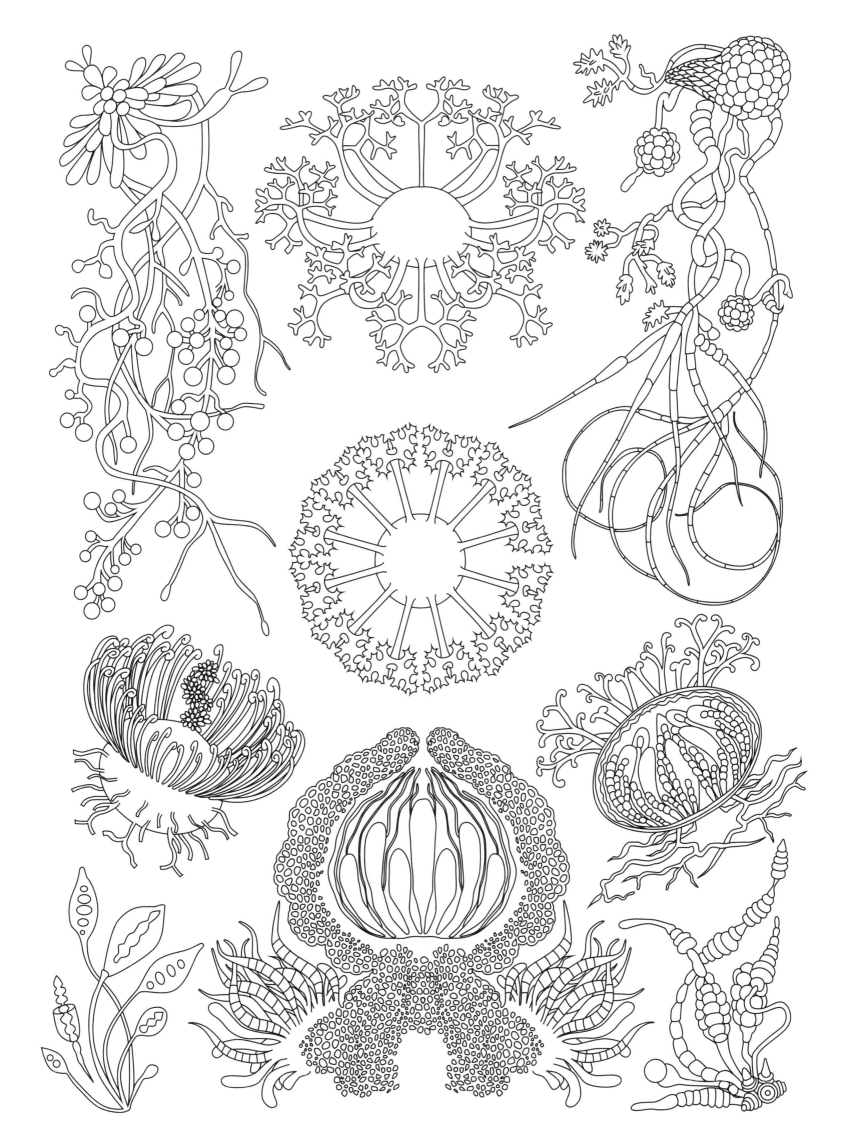

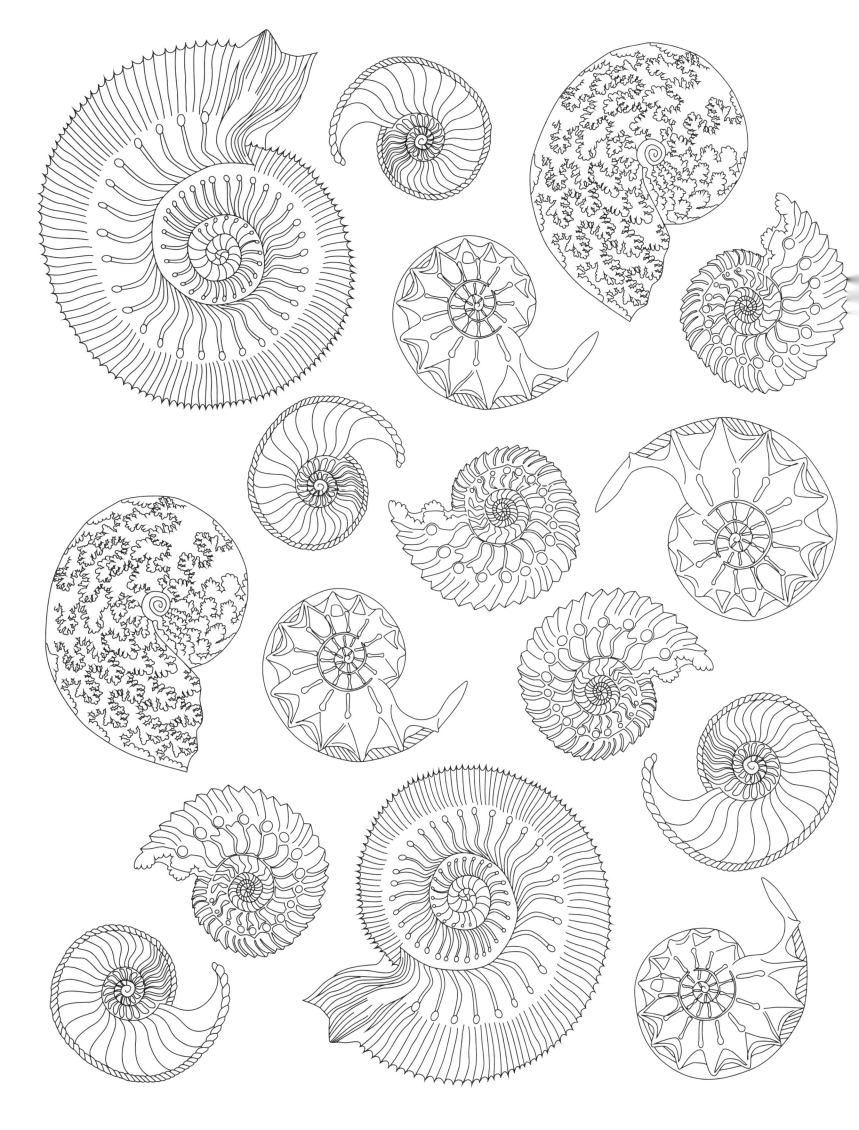

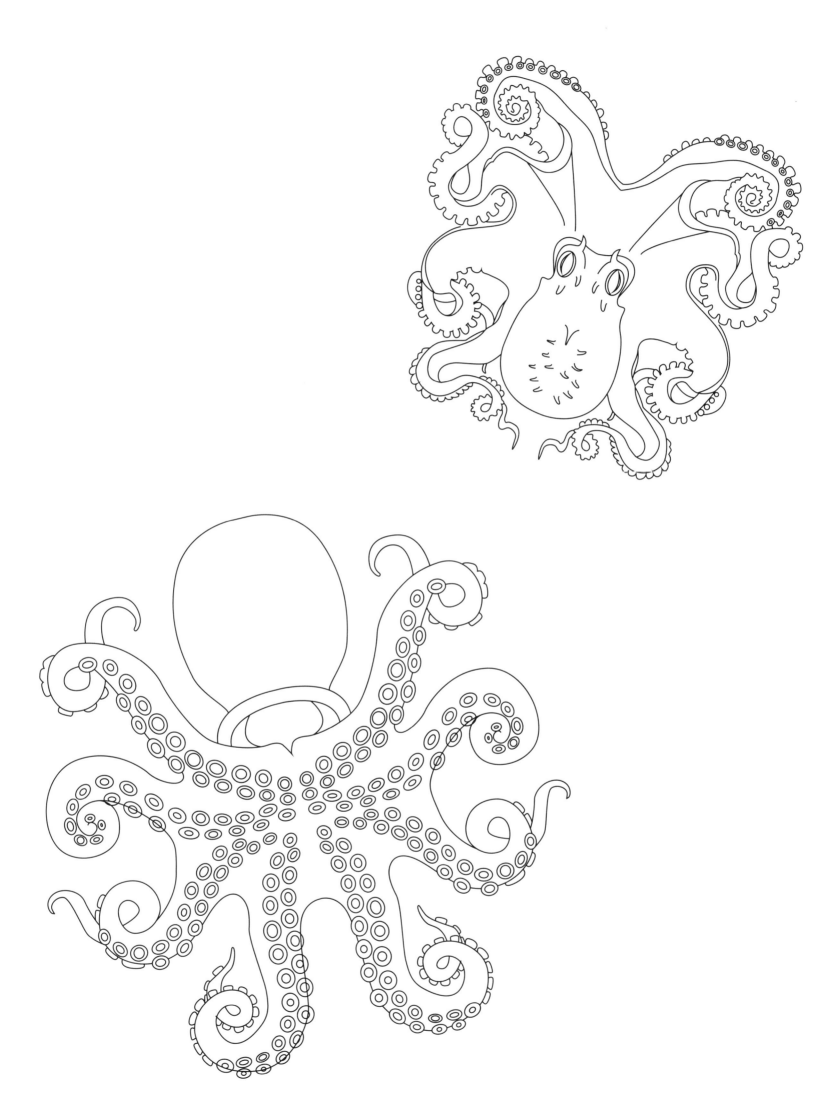

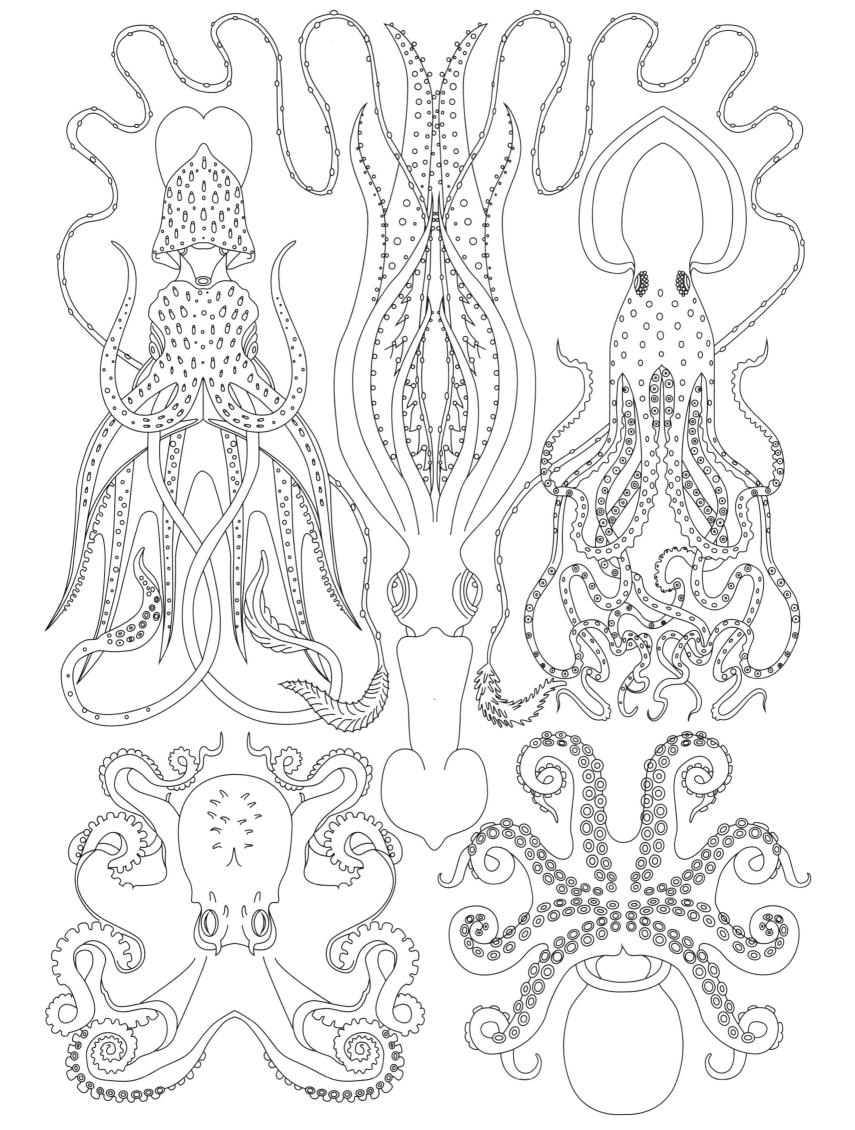

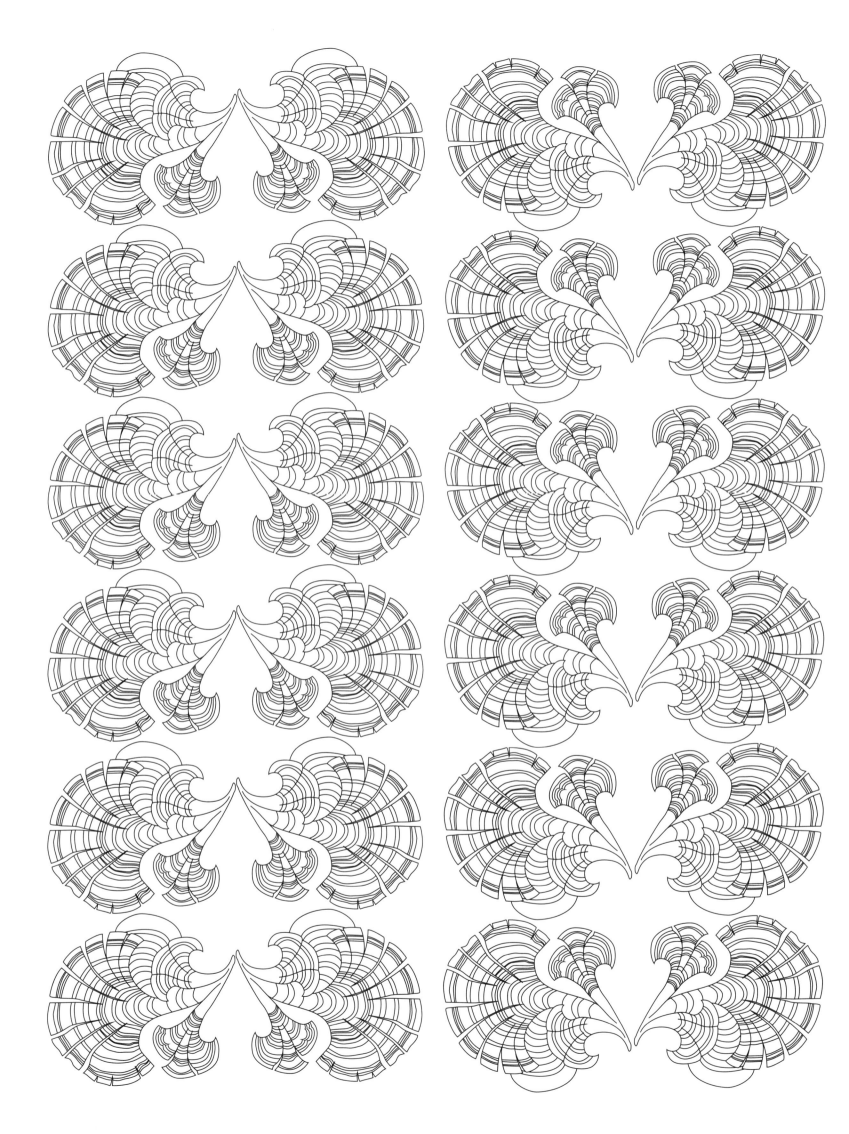

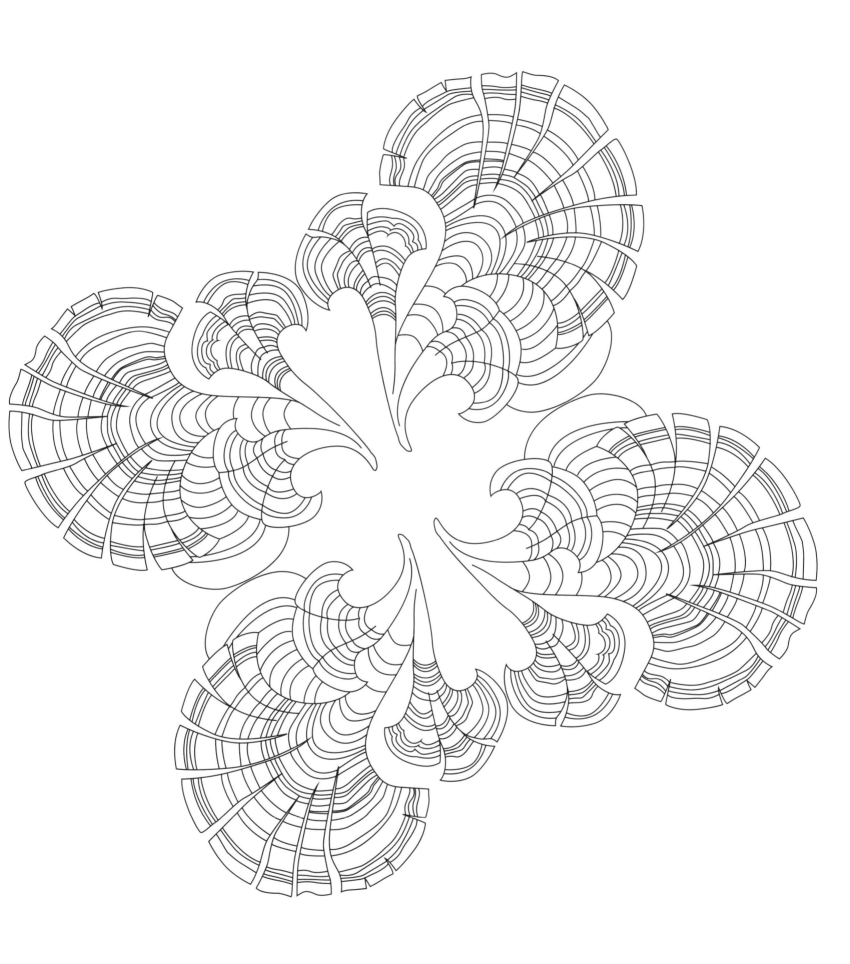

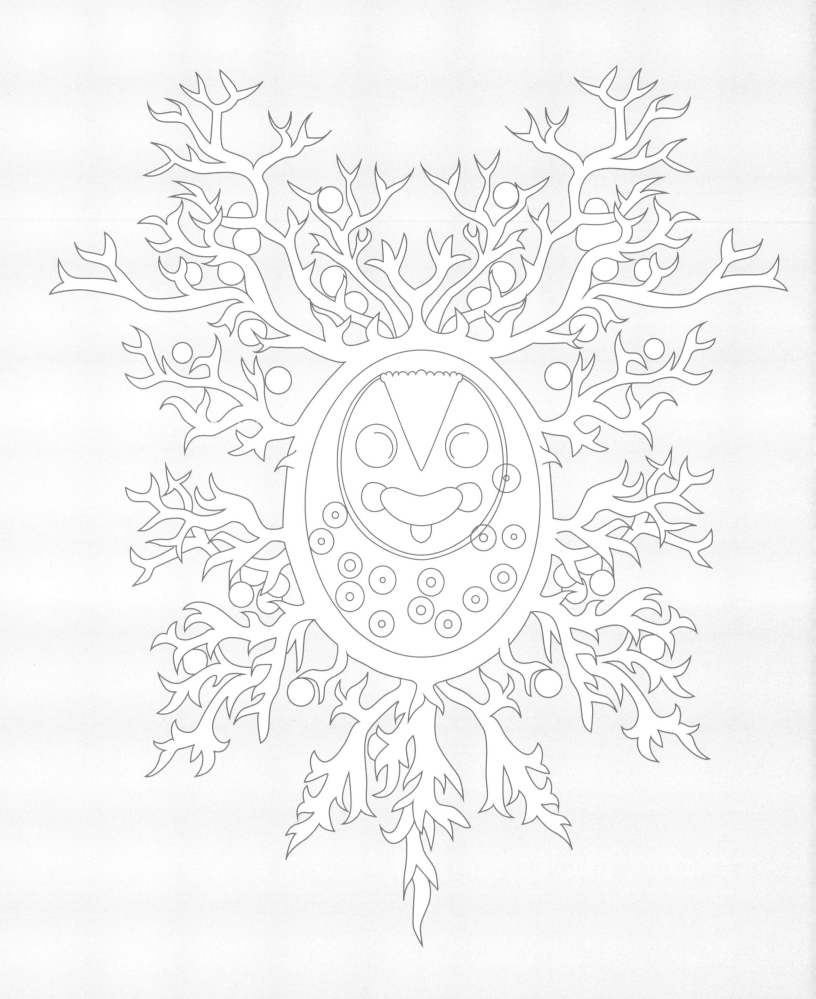

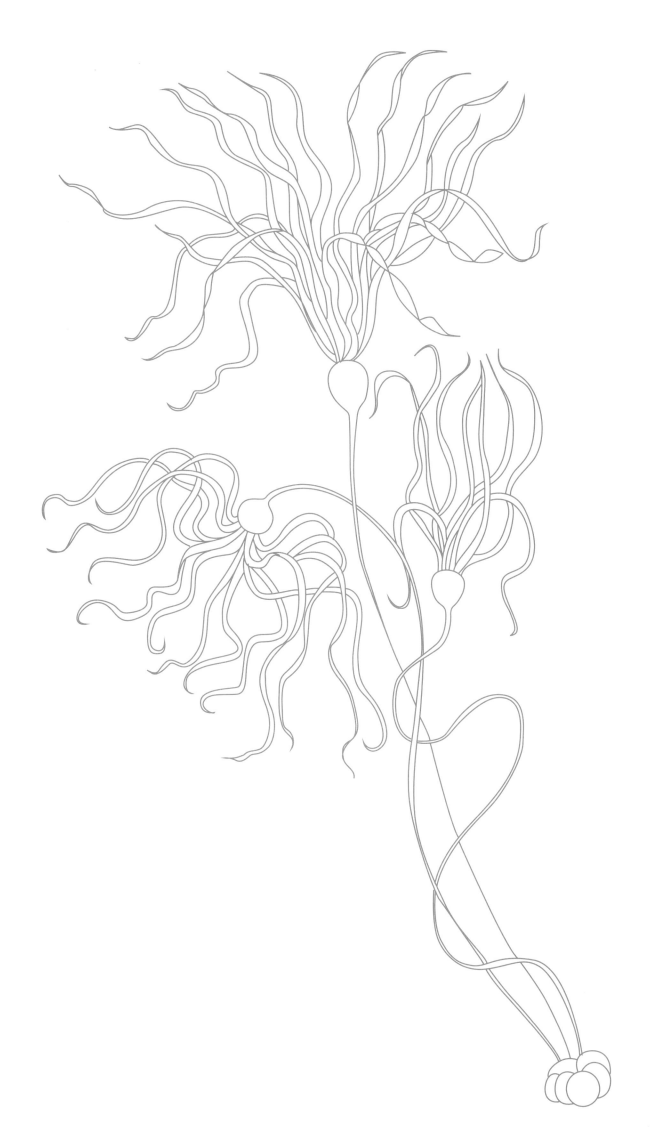

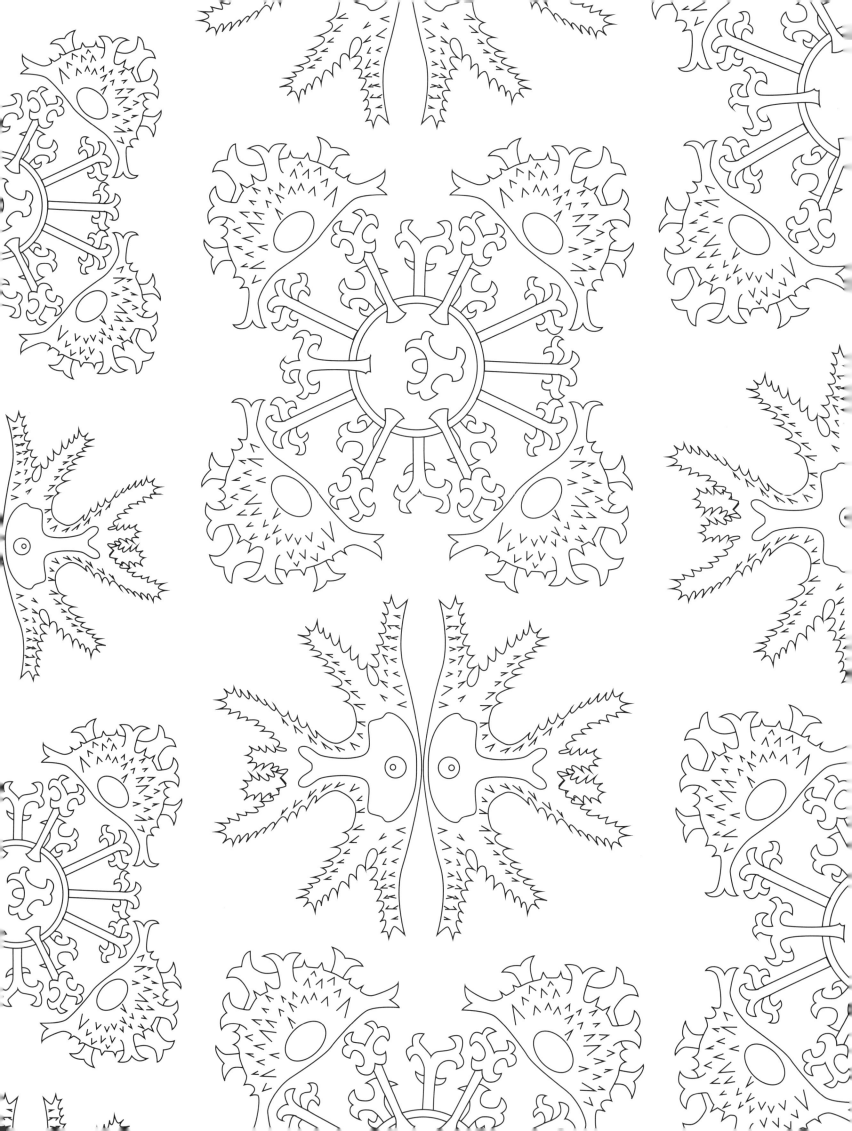

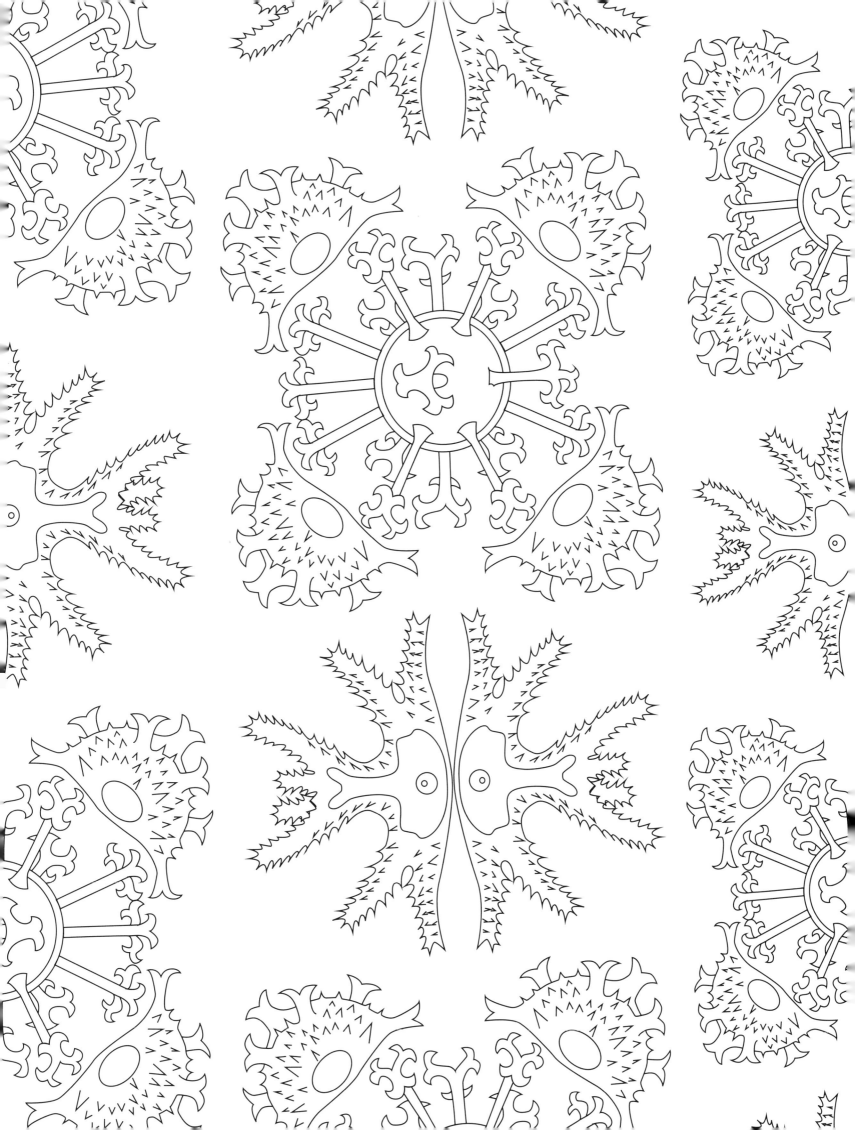

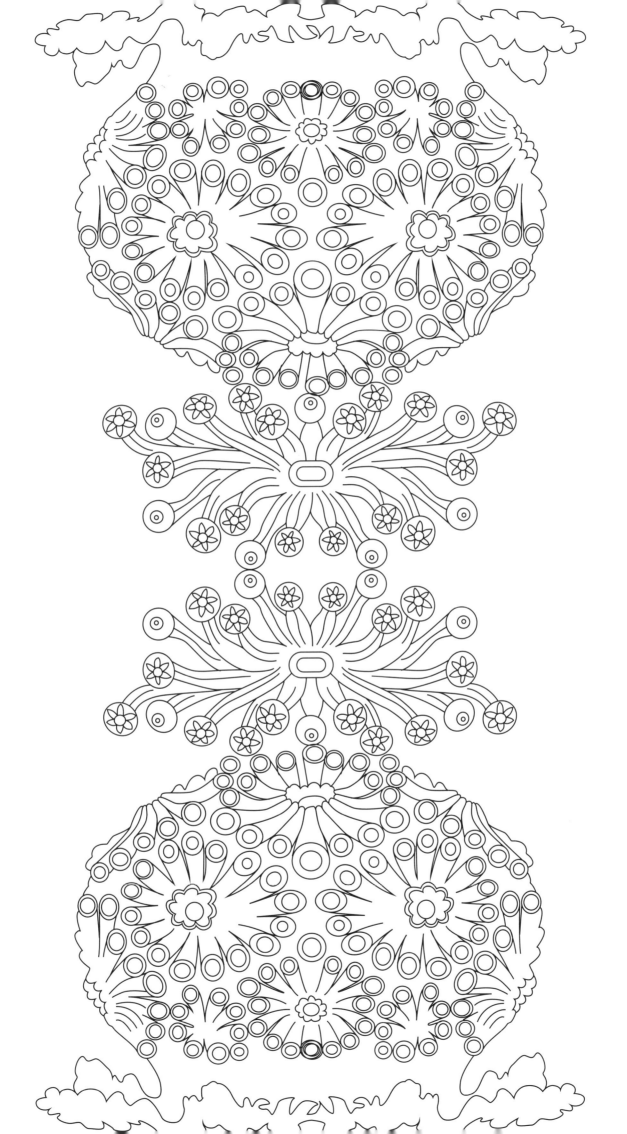

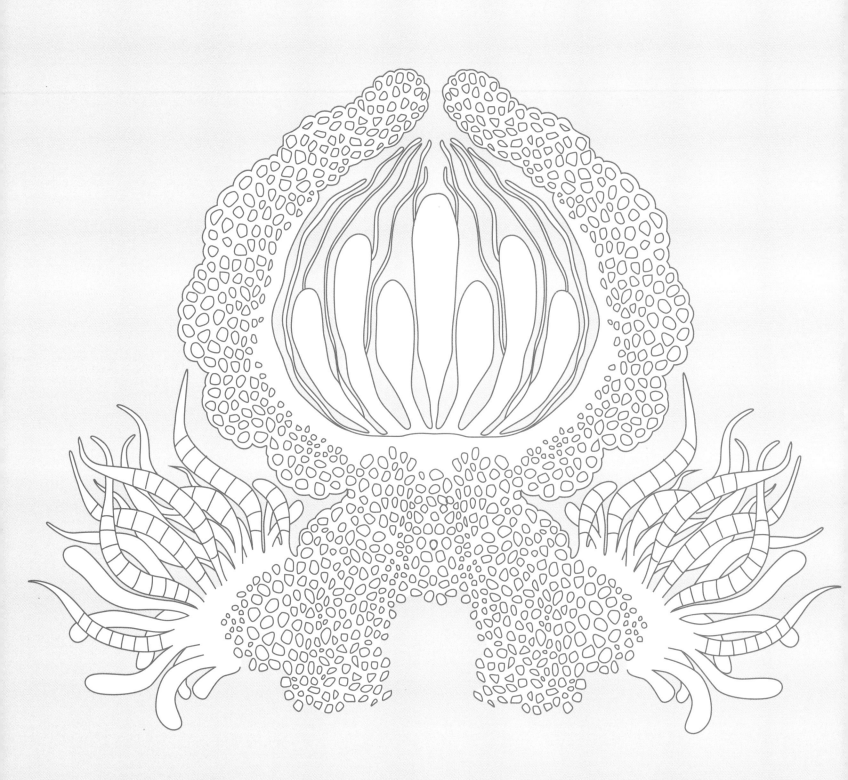

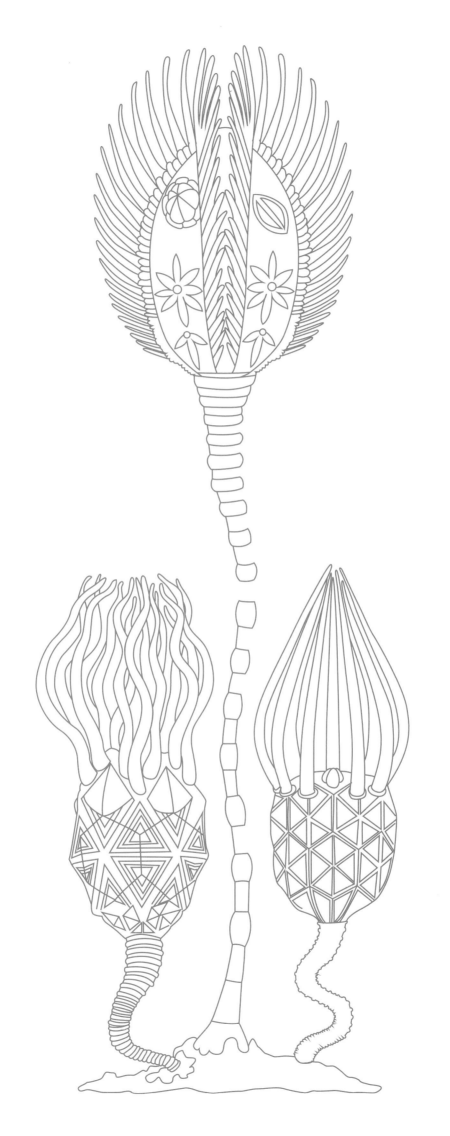

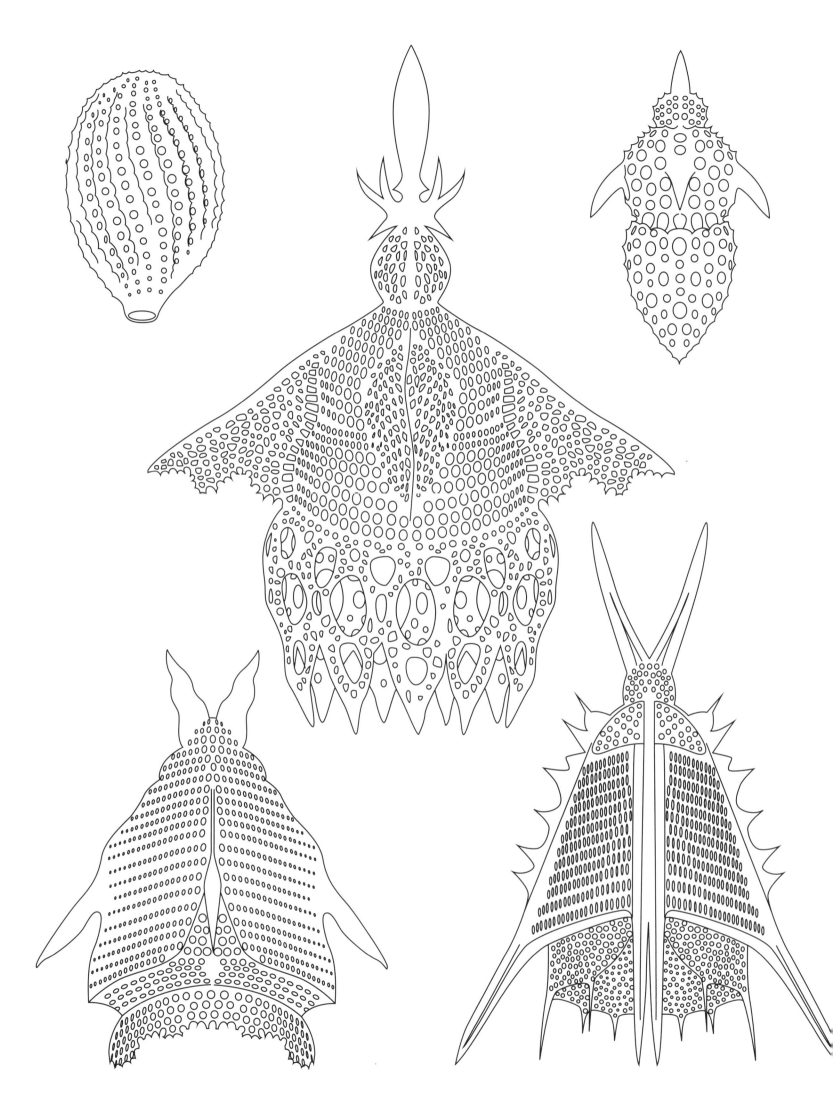

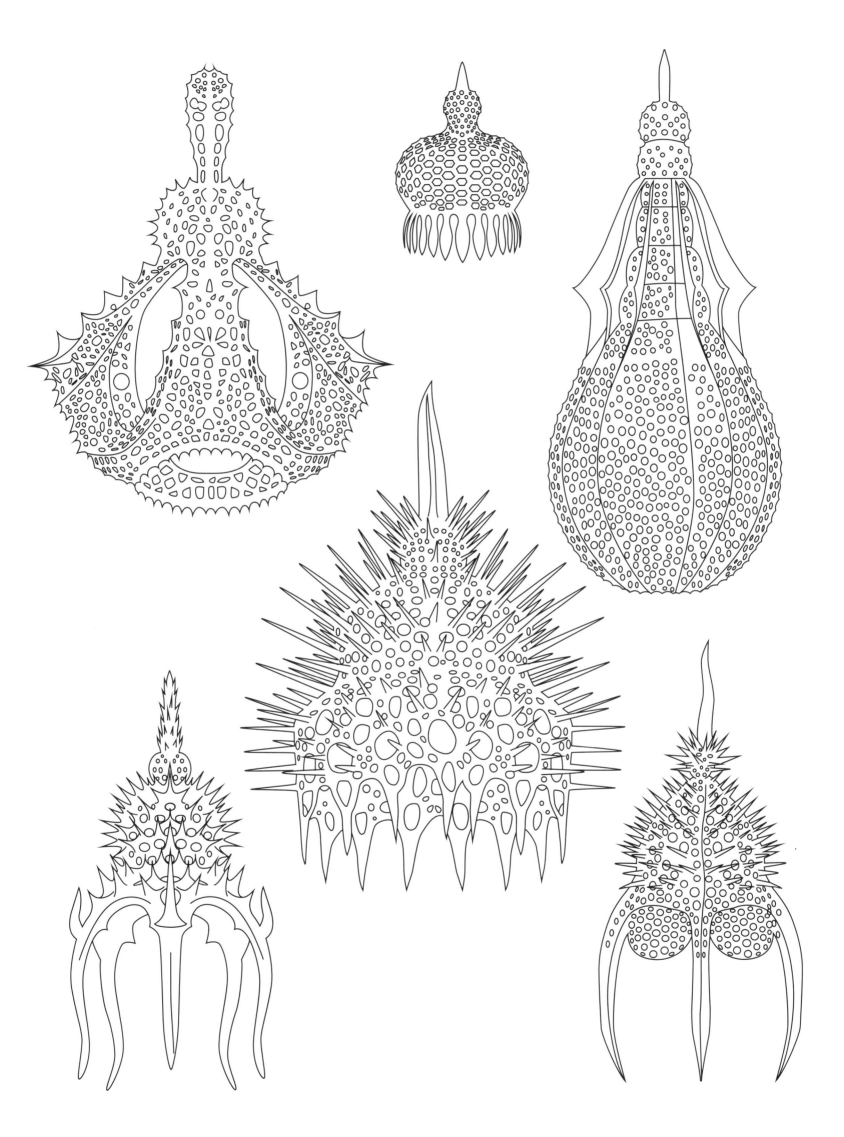

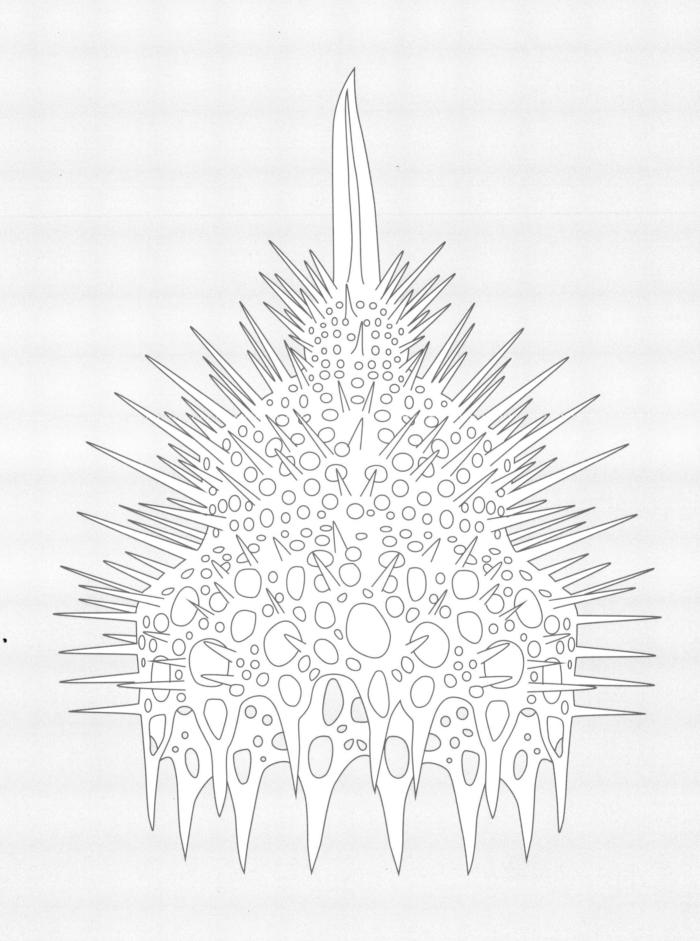